IN & AROUND THE NORTH YORK MOORS

THROUGH TIME

Alan Whitworth

AMBERLEY PUBLISHING

First published 2011

Amberley Publishing
The Hill, Stroud
Gloucestershire, GL5 4EP

www.amberley-books.com

ISBN 978 1 4456 0599 9

British Library Cataloguing in Publication Data.
A catalogue record for this book is available from
the British Library.

Typeset in 9.5pt on 12pt Celeste.
Typesetting by Amberley Publishing.
Printed in the UK.

Introduction

The North York Moors National Park (NYMNP) covers an area of 554 square miles (1,435 sq. km) and came into being in 1952. It is bordered on the east by a rugged coastline against the North Sea. The dominating feature of this Park, however, is the vast central upland tract of moorland that provides the largest extent of unenclosed heather in England and Wales – 35 per cent of the total area of the Park. Nevertheless, there are significant areas of agricultural land supporting cereal growing and dairy herds, and to the south-east are impressive swathes of woodland encompassed in the Cropton, Dalby, Langdale and Wykeham Forests.

Away from the central moorland, there are three principal ranges of hills, all of which lie along the edge of the Park – the Cleveland Hills, the Hambleton Hills and the Tabular Hills.

Dissecting the moorlands are numerable valleys – the dales – carved out by the waters draining off the central watershed. The result is not a landscape composed of a single vast moorland, but rather a collection of high moors separated by narrow, intervening dales. All the moors are individually named. The larger moors usually take the name of the nearest village or hamlet.

The North York Moors is one of the least populated areas in England and Wales. It has a total population of about 25,560 spread over its entire area. In common with many upland areas, the geography of the area has not been favourable to the growth of large settlements. Mining for alum, jet and iron-stone is a thing of the past, only the Boulby potash mine, in the north-eastern corner, provides employment in industry. Undoubtedly today, it is the rural nature of the area that confirms its position in the tourism market. Tourism has overtaken farming as the economic mainstay of the Park.

Despite the paucity of inhabitants there are over 100 villages in the North York Moors. Although the economic reliance of village life on agriculture has waned, the heritage of the past has not been overshadowed. The essential character of these villages is cherished both by residents and visitors alike. It is just one of the many responsibilities of the Park Authority to ensure that this essential character remains intact. Each settlement is a product of history with its own identity and its own mix of village hall, green, church, chapel, historical ruins, houses, cottages and lanes. Each village has a story to tell.

It is easy to recognise the traditional building materials that belong to this part of Yorkshire – stone, usually sandstone in the north and limestone in the south; and clay pantiles add the definitive, colourful, red roofs. Thatch is still seen occasionally and a few villages exhibit the use of brick and slate.

Thanks to the combination of stone and pantile, the farmsteads, village houses and buildings in the North York Moors have an unmistakable air of warmth, solidity and colour. The special qualities of the built environment are every bit as important as the natural landscape; they are part of it and form an essential feature in the character of the North York Moors. Some villages like Helmsley, Hutton le Hole and Rosedale Abbey are tourist honey pots, attracting great numbers of visitors during weekends and summer holidays.

There are no large towns within the boundary of the park. A number of market towns exist around the fringes, and the major seaside resorts of Scarborough and Whitby. Other settlements of notable size are Thornton le Dale in the south and the two coastal villages of Robin Hood's Bay and Staithes. A string of settlements in the valley of the Esk reach an appreciable size, as does the village of Osmotherley in the west.

Today, this seemingly remote landscape has become famous from numerous television series – *All Creatures Great and Small* and *Heartbeat* to name but two – that draw people from all corners of the globe. Freedom, wildness and isolation are the enduring images of a sombre moorland view, but down in the sheltered dales things take on a different character, warm and friendly – often the most treasured memory of any person's pilgrimage to this special part of the great White Rose County.

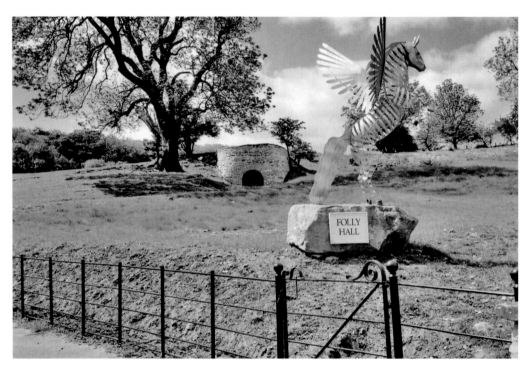

Ancient and modern found at Folly Farm, Cauton, a small hamlet between Coxwold and Hovingham. Beneath the tree are the remains of a lime kiln for rendering limestone rock into fertiliser, paint and building mortar. In the foreground, the wing horse Pegasus – one assumes because the farm now keeps race horses.

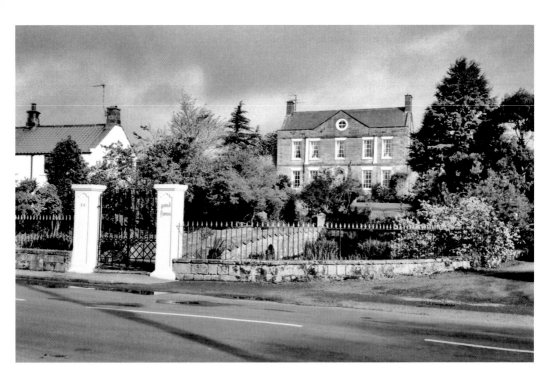

Aislaby and Pond House

On the opposite side of the valley to the village of Sleights stands Aislaby, overlooking the River Esk. There are many fine country house mansions hereabouts, and this is one; Pond House, reached over a small, decorative stone bridge that straddles the pond from which the property takes its name. A gem of an eighteenth-century home, built for one of the Whitby ship owners around the year 1789.

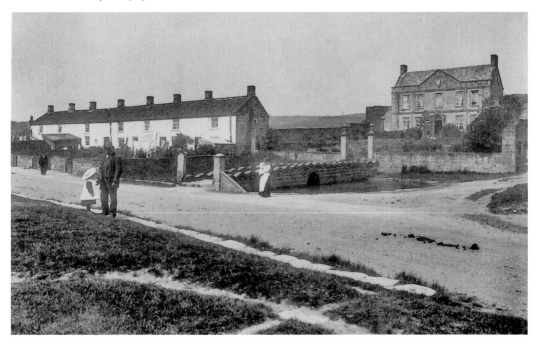

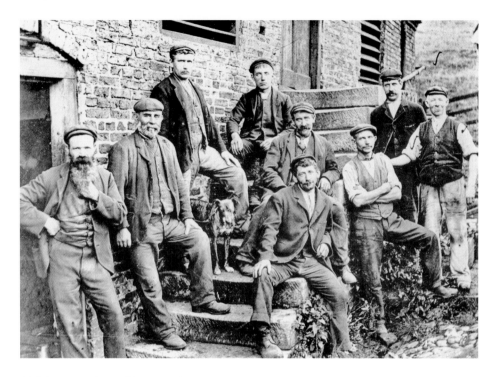

Aislaby, Upstairs and Downstairs

It was partly the tanners at Aislaby who kept the Walker family in the manner to which they had become accustomed, when they bought and rebuilt the Woodlands here over two centuries (*below*). Of course it was not just the tannery that provided their income, they had extensive alum works that were used in the leather industry, shipping to move their goods about, coal mines to provide fuel to power their machines and warm their other houses in Whitby for the ladies to stay over when they went shopping or dancing.

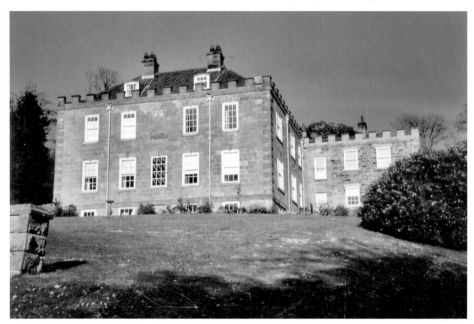

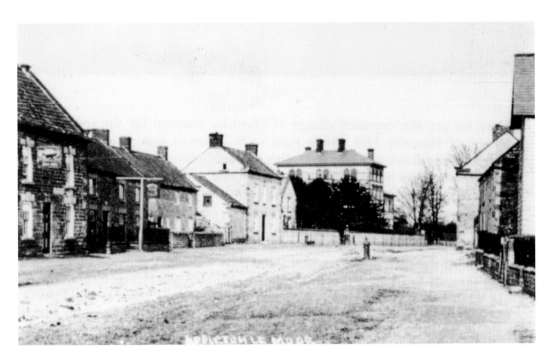

Two Faces of Appleton le Moors

Appleton le Moors lies on high ground just inside the southern boundary of the NYMNP. At the top of the single street – which, unusually, runs north to south – is the vast expanse of the moors, while to the south where the land falls away there is a far-reaching view over the Vale of Pickering to the Wolds, which are in the East Riding. The Hall, lived in by a whaler in the 1850s, is now a hotel.

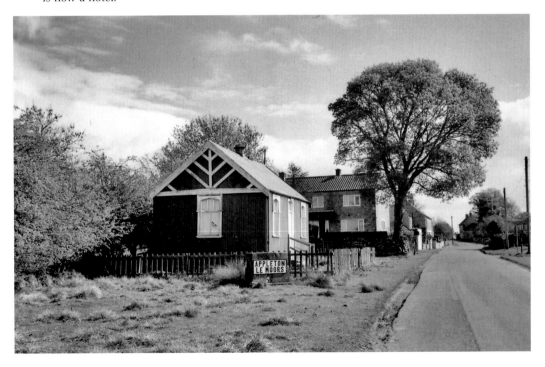

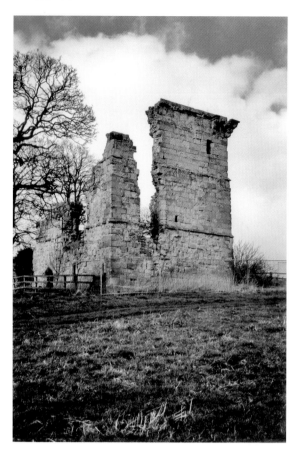

Ayton Castle, Defender of the Dales
Ayton castle sits on the banks of the River Derwent at West Ayton, near Scarborough, and is said to date from *c.* 1400, but it may be earlier. The construction is attributed to Sir Ralph Eure, and is one of numerous castles in the NYMNP. Although largely in ruins above ground, the basement or undercroft remains mostly intact, mostly due to its immense twin tunnel vault construction. Surviving corbels at the wall head are evidence that the castle had crenellated battlements.

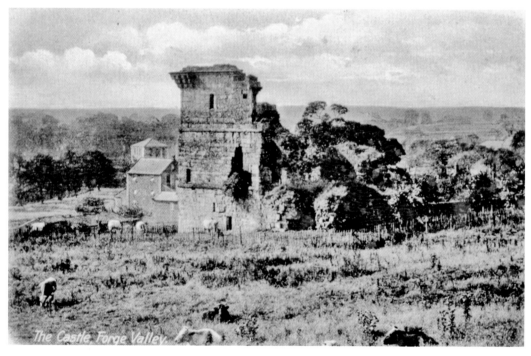

The Castle, Forge Valley.

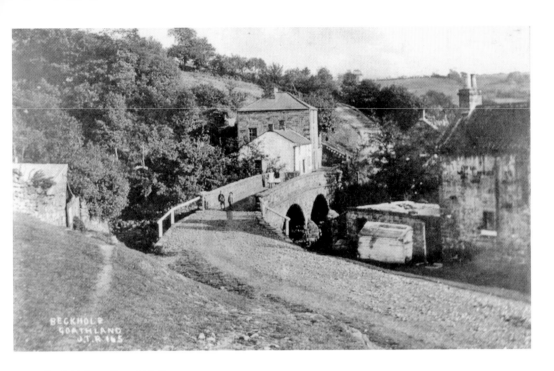

Beck Hole, a Rural Idyll

This view of Beck Hole, near Goathland, was painted as an inn sign by Algernon Newton, RA, as a mark of affection for this tiny hamlet. His first attempt was painted on asbestos and weathered badly. A second attempt on sheet iron protected from the elements with a plate of glass, to this day remains unblemished. Mr Newton, who became a member of the Royal Academy in 1943, was the father of Robert Newton, the film actor, perhaps best remembered for his role as the pirate Long John Silver from *Treasure Island*.

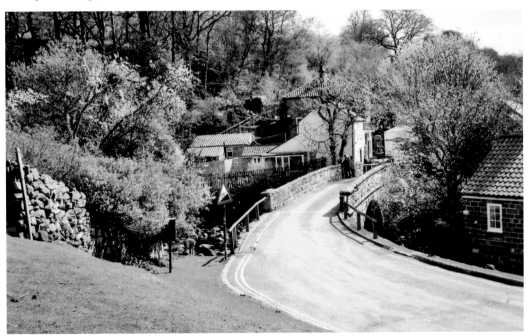

9

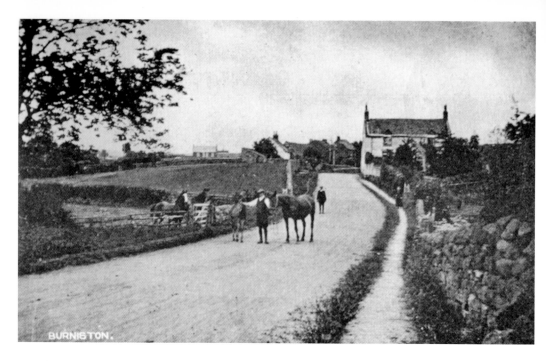

Burniston, from Horse Power to Horse Power!

Burniston, on the road from Whitby to Scarborough, near to Cloughton. The building above marks the entrance to Limestone Road, and a nearby lane is named Quarry Bank, two names that tell the story of a past industry in this now sleepy hamlet. There were smugglers in Burniston and, in 1823, William Mead, smuggler, shot dead James Law in a fall out over stolen contraband goods. A painted sign on the house wall records that Robinsons Coach Tours went from here in a later era.

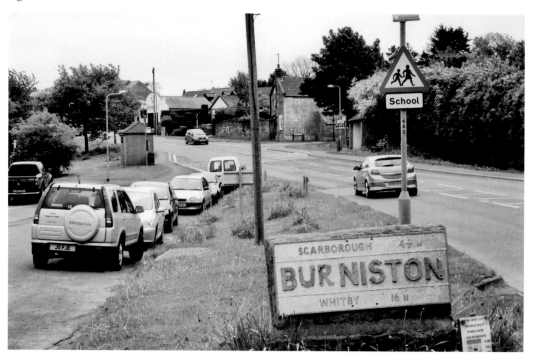

Castleton Market Square, Then and Now

Castleton was the ancient baronial capital of Upper Eskdale. It had an important Cheese Fair and regular cattle marts were held in the old market square. One of the best books on the history of Castleton was written by Joseph Ford, a resident, whose volume *Some Reminiscences of the Folk Lore of Danby Parish and District* was published posthumously in 1953. It was Mr Ford who donated the gruesome relic the 'Hand of Glory' to Whitby Museum.

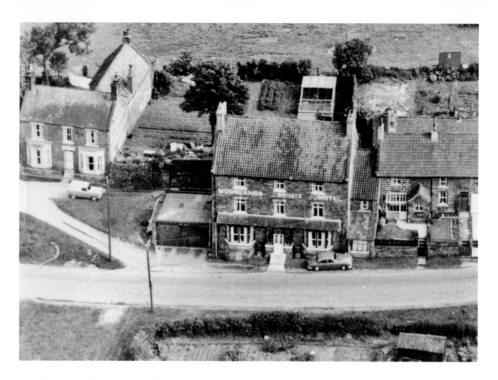

Castleton Main Street Decked Out for Royalty

Castleton Main Street from the air, showing the Moorland Hotel, which closed some years back. In its heyday, Castleton could boast many drinking houses, but today there is only one. Below, the main street decked out for the wedding of Prince William to Catherine 'Kate' Middleton on 29 April 2011, one of the few villages in the district to make the effort to hold community festivities in celebration of their union.

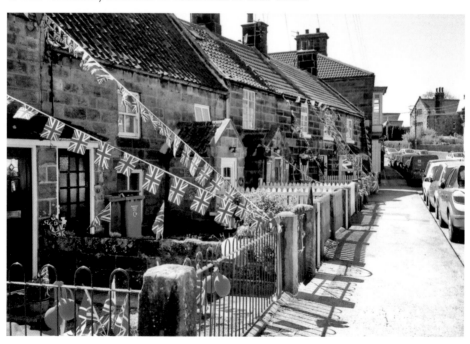

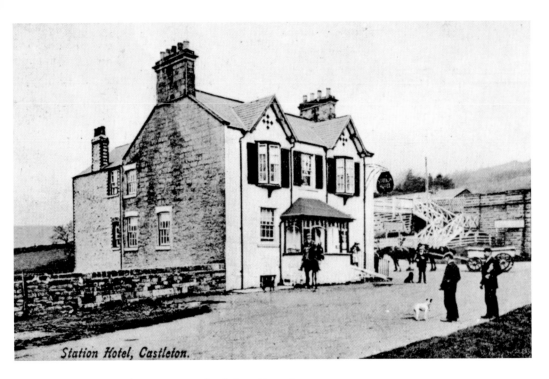

Station Hotel, Castleton.

Station Inn, Station Tavern; What's in a Name?

Out of Castleton on the road to Guisborough, and just over the bridge spanning the River Esk in the valley bottom, sits the Station Hotel, behind which is the village railway station – almost a mile from Castleton centre. In times gone by, it was from here that the local hunt met regularly before fox hunting was banned. Later it changed its name to the Eskdale Inn and you could get your 'day fishing' license at this establishment.

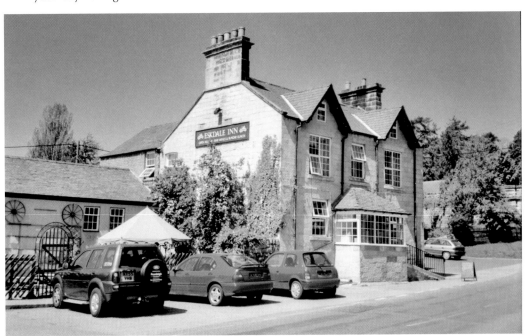

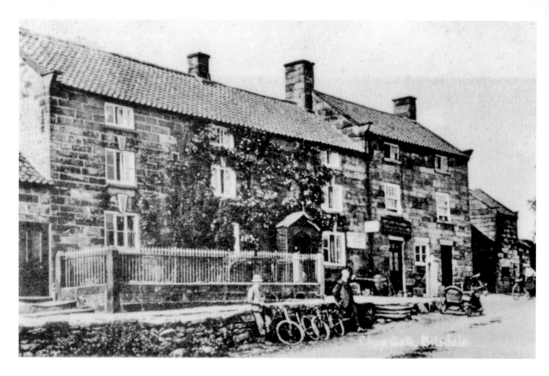

Chop Gate, and a Man of Many Talents

Chop Gate, pronounced in Yorkshire as 'Chop Yat' – 'Yat' being the Yorkshire dialect name for 'gate'. From 1890 William Allenby ran the post office, and also a store, petrol station and the Commercial Hotel here until the 1920s and 1930s. The road to Helmsley forks round to the right at this point, and a second road is a byway to Rainsdale and over Carlton Bank. Today this property is residential dwellings.

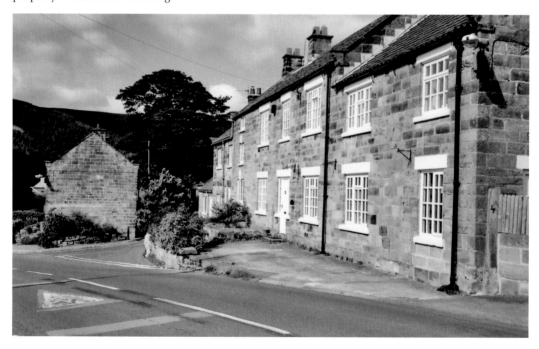

Flotsam and Jettison at Cloughton

Cober Hill Guest House at Cloughton, near Scarborough, marks the southern edge of the NYMNP. The guest house still survives though much enlarged, but was originally built for a media magnate who ran newspapers in Hull. The beach at Cloughton is more stone than sand, but nevertheless visitors manage to enjoy themselves sunbathing. Unfortunately, the tides can be treacherous and, in September 1910, a whale was forced onto the rocks and died, a regular occurrence over the years hereabouts.

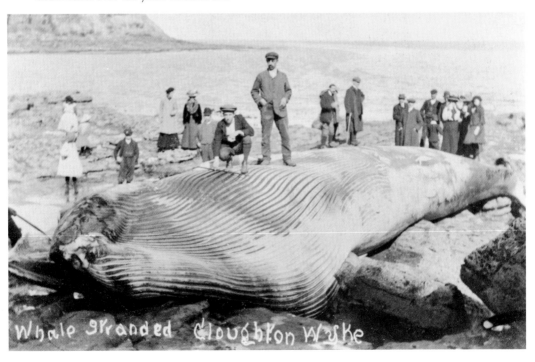

Whale stranded Cloughton Wyke

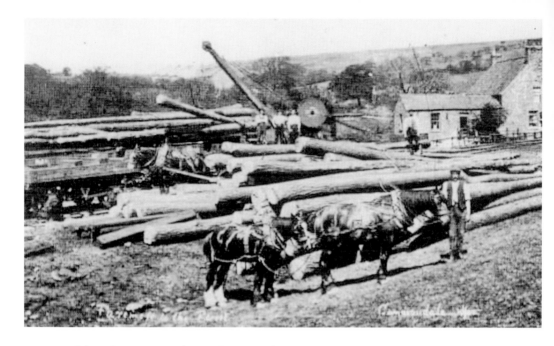

Commondale, Where You Can't See the Wood for the Trees

The scene above was probably taken around 1920 and shows heavy timber being loaded onto rail wagons in Commondale village. The logs were brought from the forests by horse-drawn wagons from North Ings above the village off the road to Kildale. The Cleveland Inn can be seen on the right and still stands (*below*). Unusually for the area, Commondale is largely a village of brick, as there was a major brickworks situated here for many years. The red brick building below, left, was the village hall but is now a home.

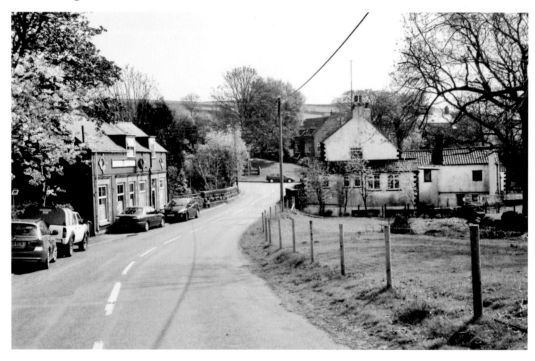

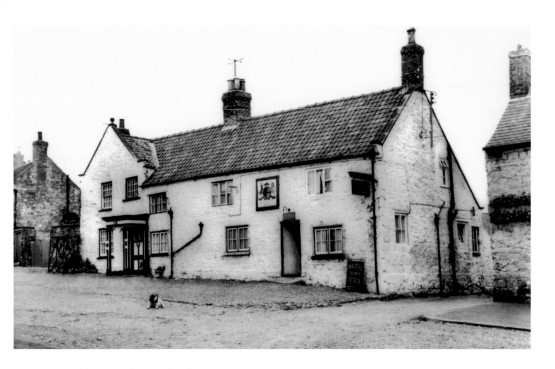

Coxwold, an Ancient Splendour

The Fauconberg Arms, at Coxwold, takes its name from the lords of the manor who lived at nearby Newburgh Priory. Coxwold is one of the prettiest villages in the park. It sits on the edge of the Hambleton Hills, about twenty miles from York and not far from Thirsk and Easingwold. Among the historic buildings are the Old Hall, built in 1603 as a free Grammar School, Colville Hall, the ancient manor house, and the almshouses found in 1662 as a hospital for 'ten poor and infirm men'.

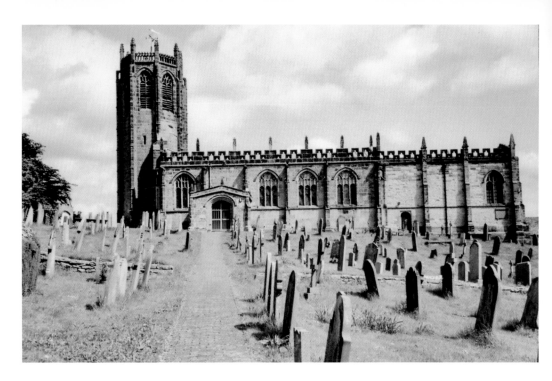

The Church of St Michael, Coxwold
The church of St Michael, at Coxwold, is one of the most splendid in North Yorkshire and has two unique features. Its octagonal tower – the only one so shaped from the ground to crenellations – and the horseshoe-shaped altar rail (*below*) in the chancel, which is so packed with monuments to members of the Fauconberg family it had to be constructed in this manner as the only way to allow large numbers of communicants to kneel for Holy Communion.

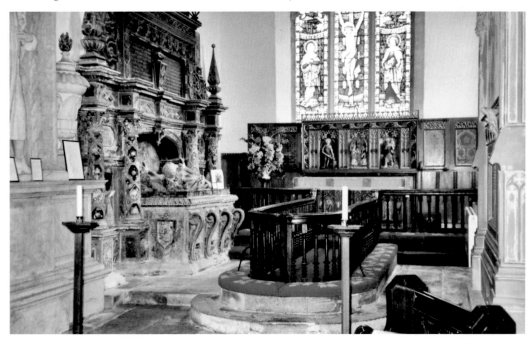

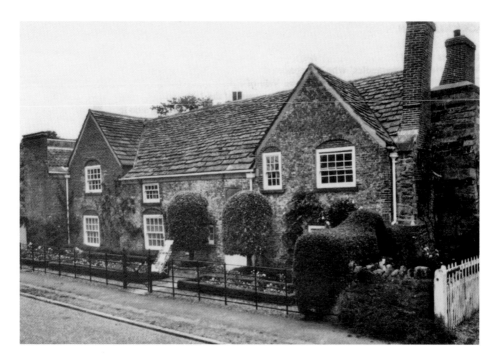

Shandy Hall, a Literary Gem

Among the interesting buildings of Coxold is Shandy Hall. Erected as a medieval priest's house, it became famous as the home of the Revd Laurence Sterne, parson at Coxwold in the eighteenth century, who wrote *Tristam Shandy* and *A Sentimental Journey*. These were considered somewhat scandalous when first published, but have become enduring classics and are considered the beginnings of the modern novel. The Revd Sterne was interred in London but, in modern times, he was brought back to Coxwold and now lies in the churchyard of St Michael.

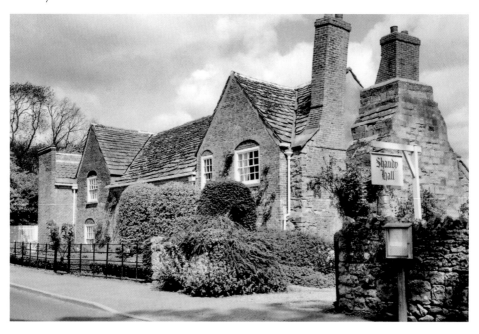

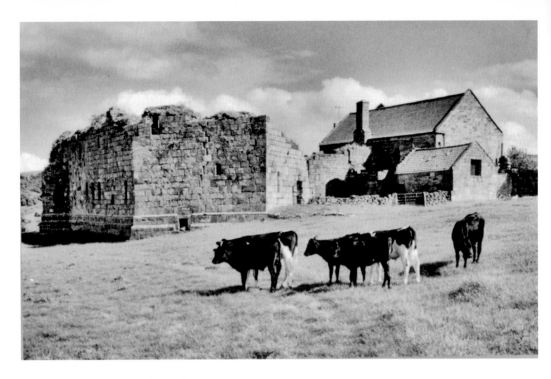

Danby Castle, the Seat of Royalty

The situation of Danby Castle is exceedingly fine, strategically placed on a hillside with panoramic views of the valley. Built between 1296 and 1300, by an ancestor of the Brus family, from whom are descended the kings of Scotland. It came into the possession of the Neville family by marriage. It was here that Catherine Parr, the surviving wife of Henry VIII, lived. The ancient Court Leet still meet in a room at Danby Castle as they have done for centuries, and are responsible for keeping order in the valley.

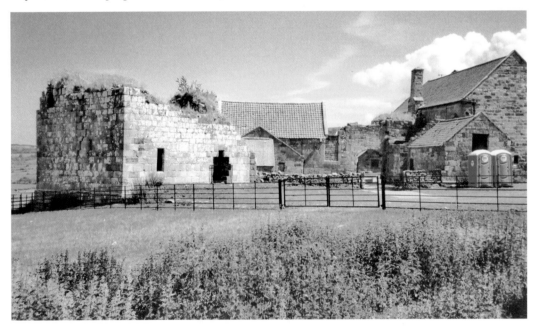

A Quiet Corner of Danby

Danby village proper lies about half a mile from Danby Lodge, and sits on the banks of the Esk. From here the hills rise to 854 feet at Job Cross, and an even greater altitude still westward on Commondale Moor. At nearby Danby Beacon, another high point in the district, an important radar listening post was set up during the Second World War to track enemy aircraft flying over Northern England.

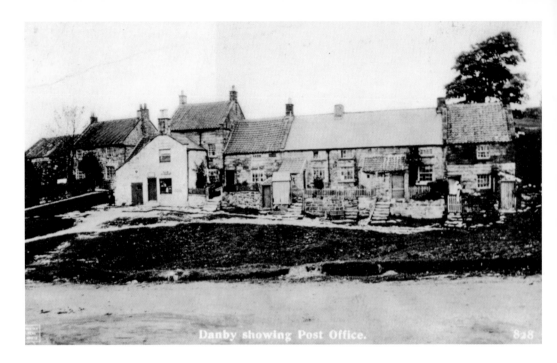

Danby showing Post Office. 828

Danby Village Centre

These old properties formerly stood at Briar Hill, Danby, photographed about 1920. The post office was then run by John Clemmit. Only the house on the extreme left still stands. The open land in the foreground was locally referred to as 'Tin Pot Alley' because some of the residents of the houses ran hardware shops in nearby towns. These properties shared an outside toilet, seen at the extreme right of the photograph. Today, the post office has closed and is now a health food shop.

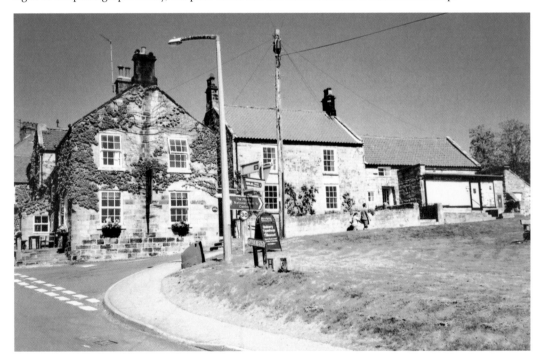

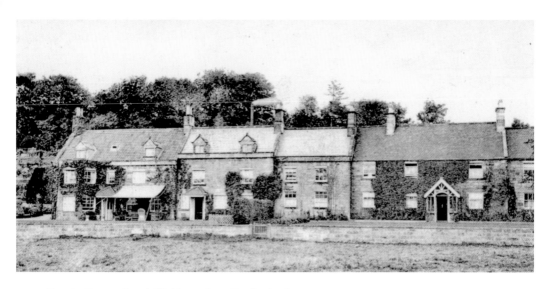

People Power, Read All About It at Danby Lodge

Danby Lodge in 1630 was known as the 'Low House' or 'Bank House'. In 1655, the estate was sold to the curate of Danby. He left the property to his granddaughter, Susannah, in 1677. She married George Duck, and with his death the property went to their eldest son, Daniel. In 1746, Daniel left it to his son George who, in 1758, sold it to Viscount Downe and it was his family who adapted the building for a shooting lodge. Later it was let to the NYMNP as a Visitor Centre.

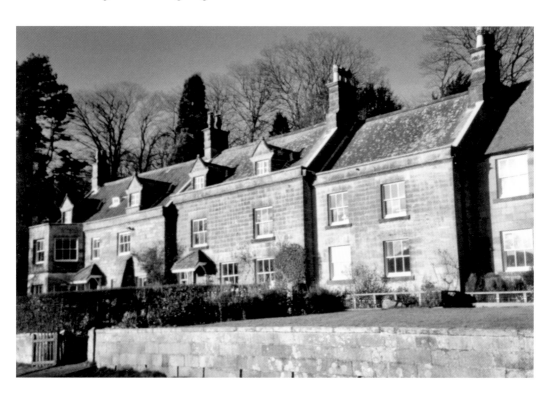

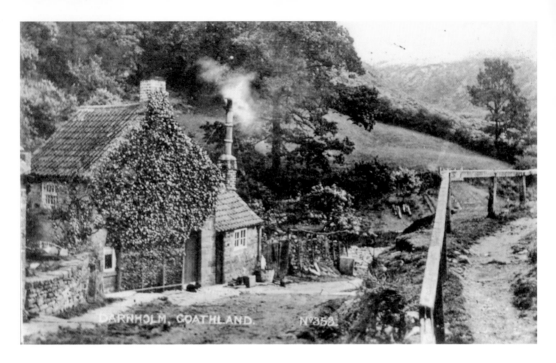

Darnholme, the Quietest of Them All

Darnholm, a small hamlet reached by a narrow, twisty byway from Goathland. The road crosses a beck by means of a ford, and a resident who lives in the cottage that can be seen in both photographs – albeit now enlarged and modernised in the bottom view – told me that the waters often rise in winter, but he has only been flooded twice in the twenty-five years he and his wife have lived there. The ruined building in the bottom illustration (*extreme left*) was once a flourishing cobbler's shop.

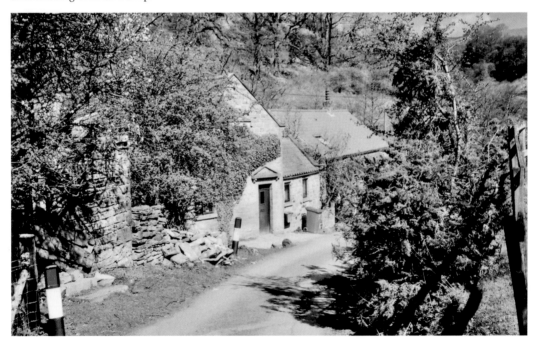

Scalley Bank, Out of Egton Bridge

Scalley Bank climbing out of Egton Bridge in one direction. In the sixteenth century, most of the cottages of the district were cruck-built and had thatched roofs; today considered the epitomy of a 'rural idyll', but the reality was that these humble homes were often dark and damp inside having only small windows. The old photograph was a carefully posed study by F. M. Sutcliffe, and the woman and children are thought to be his wife and family.

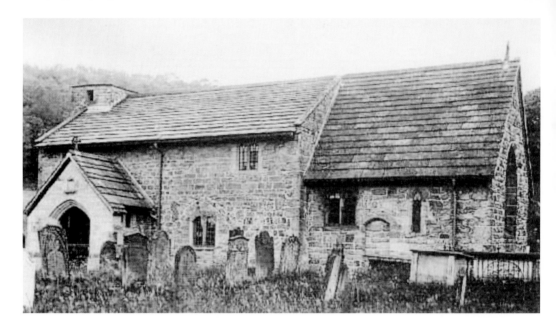

St Hilda's Church, Ellerburn

By taking a path from Thornton-le-Dale, you can reach the secluded Ellerburn valley and the charming church of St Hilda. Carefully restored, it contains good examples of Saxon and Norman work. A former caretaker here once used the eighteenth century pulpit to hatch his hen's eggs; as a consequence the preacher had to give his sermons from the reading. In the churchyard, entered by a beautiful lychgate dated 1904, is a large, red granite Dobson monument of 1879 with a stone finial and Gothic detail.

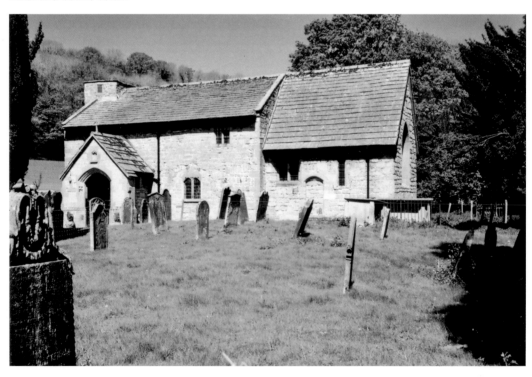

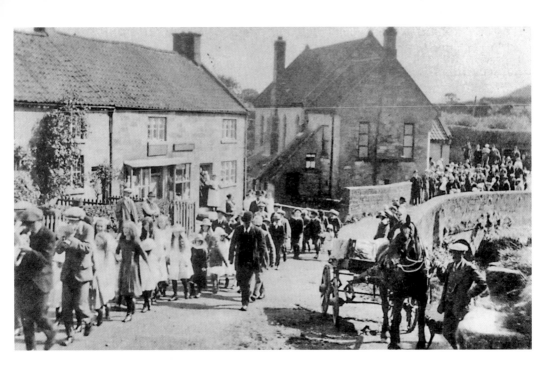

Farndale, a Springtime Delight
Celebrations to mark the anniversary of Low Farndale Methodist Chapel on 27 August 1926. The man holding the horse is Joe Carter who owned a shop in High Farndale. Farndale, which sits in a steep-sided valley through which flows the River Dove, is famous for its wild daffodils (*Narcissus pseudonarcissus*), also known as the Lent Lily. It is thought that the monks from nearby Rievaulx introduced the flower and, over several centuries, they have multiplied.

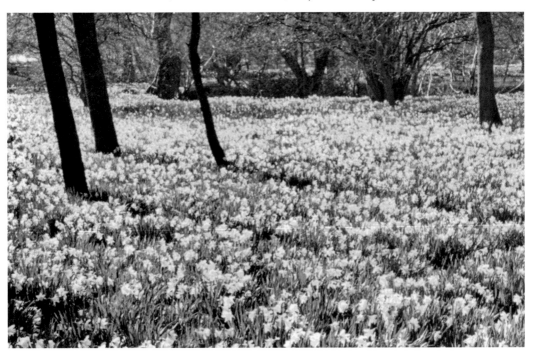

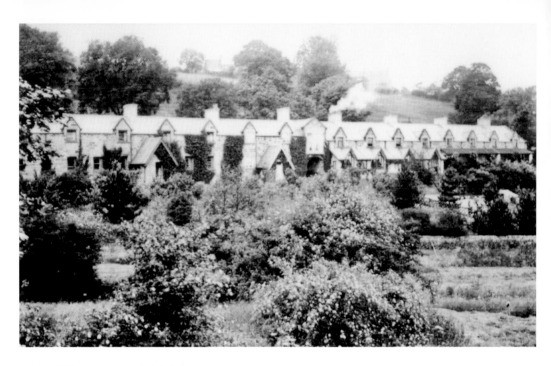

Undercliffe Cottages, Glaisdale

Glaisdale is a straggly village rising up from the river at Beggar's Bridge and then dipping down into a fold in the earth to climb up the other side. Like Grosmont, it had an industrial past of which only this terrace of miner's cottages – known as Underhill – and a number of landscaped spoil heaps, survive. Despite its period of industrialisation, the farming is good and there are a number of farms, two of which were named in the Domesday Book. Two still have their 'witch posts'.

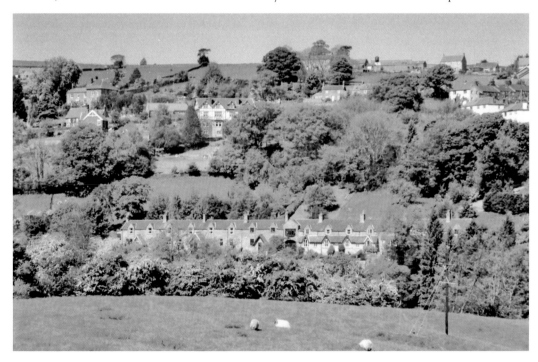

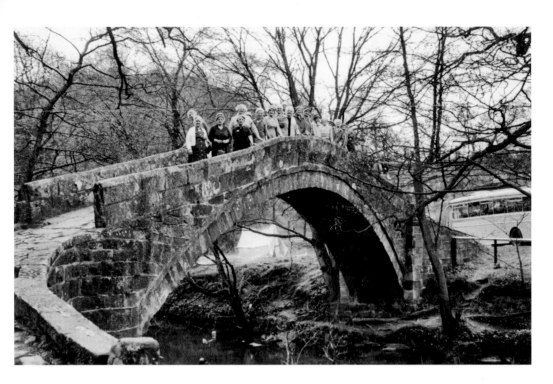

The Beggar's Bridge, Glaisdale

One road leads out of Egton to Glaisdale, and here the road crosses the Esk by way of Beggar's Bridge – an old pack-horse bridge. The name Beggar's Bridge was given to it in memory of an old story concerning its erection, arising from a romantic tale of two local lovers of whom the man made a promise to build a bridge here where they met if he became rich – he made good his promise in 1674.

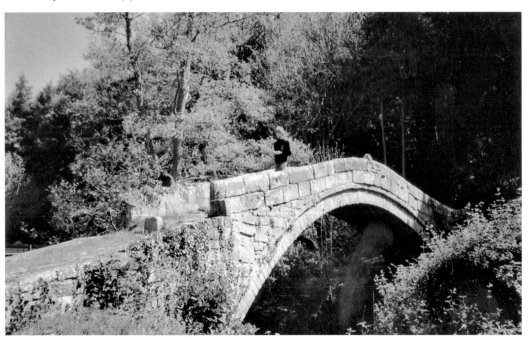

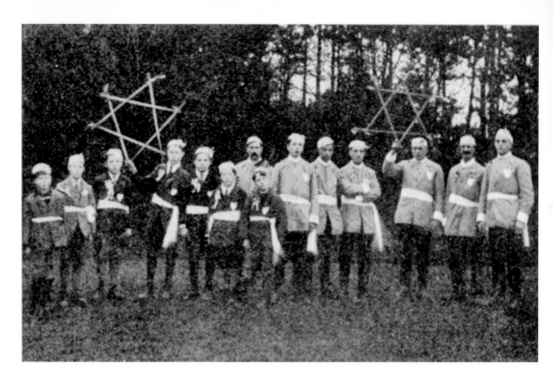

The Goathland Plough Stots at Rest
Members of both the junior and senior Goathland Plough Stots Sword Dance team, with their swords arranged in the Star of Bethlehem formation. The dance itself, performed annually on the first Saturday after Plow Monday, has its origins in the mists of time and is said to be derived from a Viking fertility dance. The dance is intended to banish evil spirits and guarantee a good harvest. The headquarters of the dance team is the Goathland Hotel.

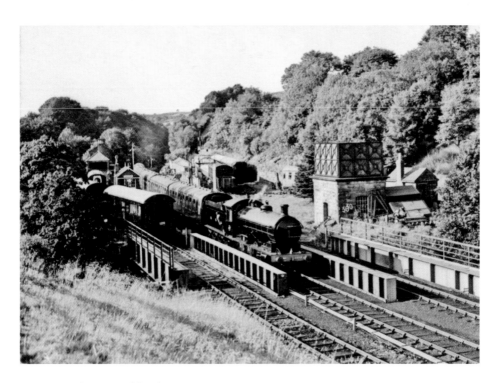

Potter Mania at Goathland

Goathland of course, is best known for the setting to the TV series *Heartbeat*, based on the books of a retired policeman. However, in more recent times, it is possibly familiar to a younger generation as Hogsmead Station, the stop for Hogwarts School of Witchcraft and Wizardry in *Harry Potter and the Philosopher's Stone*. Goathland Station was built in 1865 and today forms part of the North York Moors Railway, a preserved line running from Grosmont to Pickering.

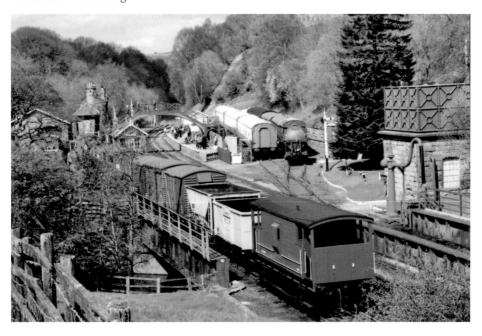

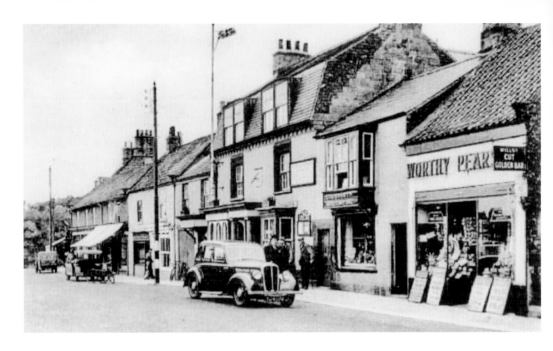

Around the World, from Great Ayton

Great Ayton, the boyhood home of James Cook; a modern statue of him as a youth stands along the High Street, seen here, and on one side is a huge expanse of grass known as High Green. It was sculpted by Nicholas Dimbleby and unveiled on 12 May 1997. The Cook family moved here in 1736, and the cottage that was their home was meticulously dismantled stone by stone and shipped to Australia, then rebuilt. The school that young James attended here is now a museum.

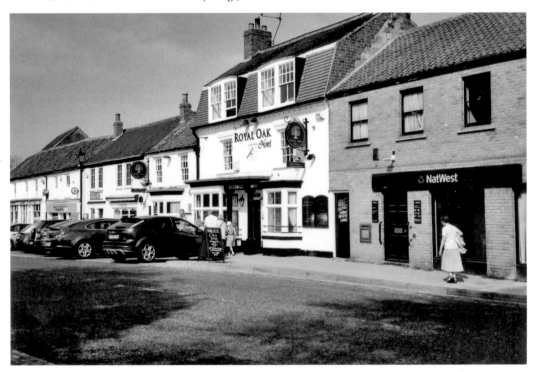

Grosmont Village Centre
Grosmont, the junction where the Whitby–Pickering Railway – known as the North Yorks Moors Railway (NYMR), a preserved line staffed by volunteers – and the Whitby–Middlesbrough Railway part company. The building here is the Co-operative store. In a small community the Co-op played a major role in village life. It was founded by local residents in May 1867. In 1900, the store was enlarged. Today it is still a truly run co-operative managed by the villagers.

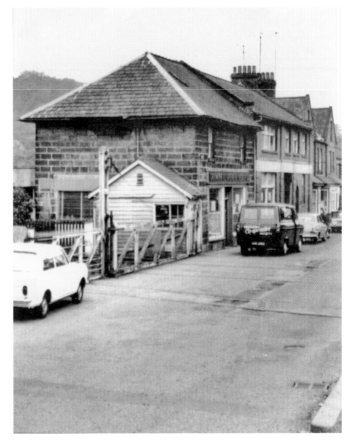

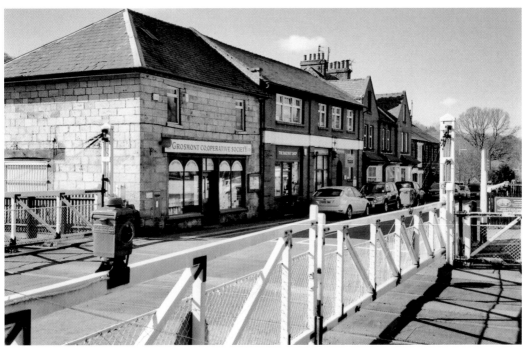

Railway Classics at Grosmont

The North York Moors Railway Preservation Society was formed in 1967 with a staggering 9,000 members. In an initial phase they bought the section of railway from Grosmont to Eller Beck and the North York Moors Railway was opened in 1973 by the Duchess of Kent. Over time, they gradually extended operations saving rolling stock, steam engines and railway buildings. Today 300,000 journeys are made each year. The engine shed and workshops, where visitors can see volunteers working on restoring engines, are at Grosmont.

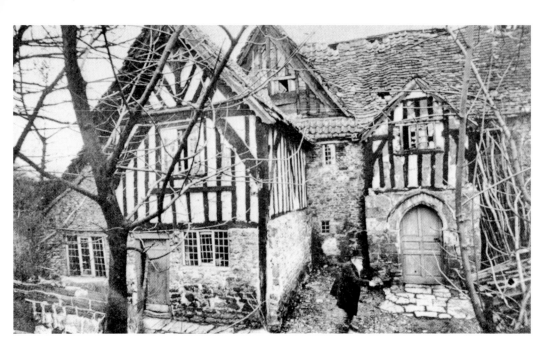

Ancient Ecclesiastical Roots at Helmsley

Canon's Garth was originally built to house the Augustinian canons of Kirkham Abbey. It then became the residence of John Manners, brother of the Earl of Rufford. In 1860, it became two cottages whose occupants left it derelict. In 1893, it was restored and let to the Sisters of the Holy Rood. In 1953, it was again divided into houses, one for the use of the curate. Today it is again empty and awaits a new owner as the Diocese has sold it off and built a modern vicarage nearby.

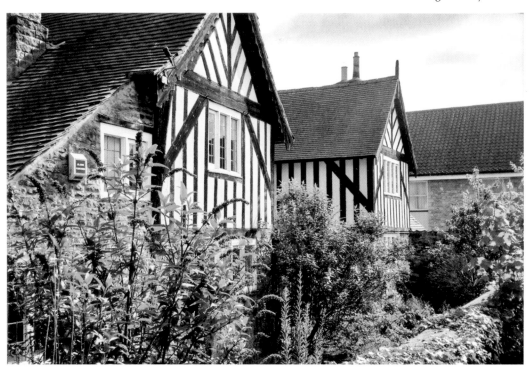

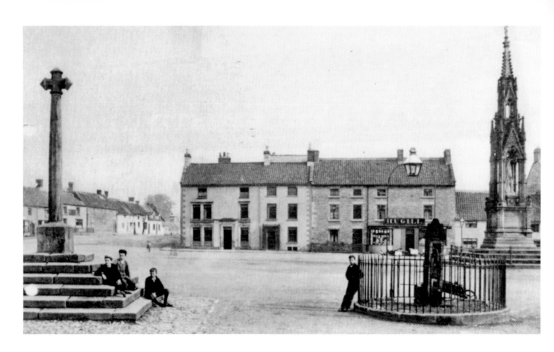

Helmsley Market Square

Helmsley is a market town and here are the headquarters of the National Park. The large car park is the market square and the medieval market cross still survives, as does the weekly market, which is still popular. The other obelisk is the Lord Faversham Memorial. The Lords Faversham still occupy nearby Duncombe Hall. In the foreground is a public water fountain enclosed in iron railings. This, however, is no longer here. Some of the cottages along Bondgate, in the background, are thatched.

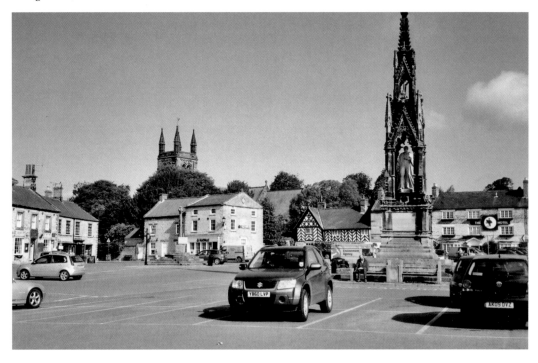

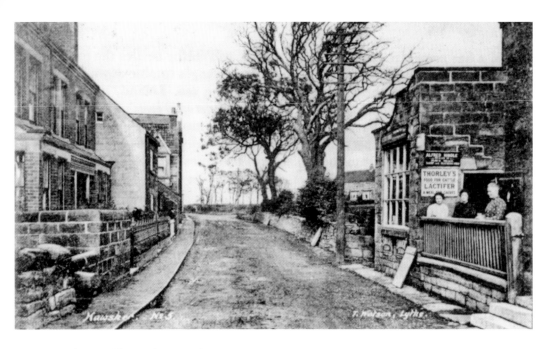

Hawsker, a Village of Two Halves

The village of Hawsker is split into two communities: Low Hawsker across the main highway to Scarborough and High Hawsker, here, on the other side of the road. High Hawsker has the sole public house and now, some new housing, below. Low Hawsker, however, could boast of a windmill of which the truncated shell survives and today, it has the village hall. There are also a number of small caravan sites as it is popular with visitors having easy access to Whitby, Scarborough and Robin Hood's Bay.

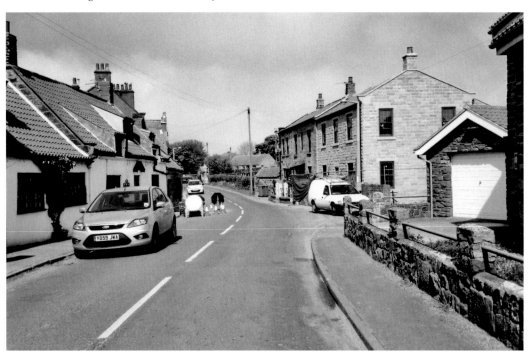

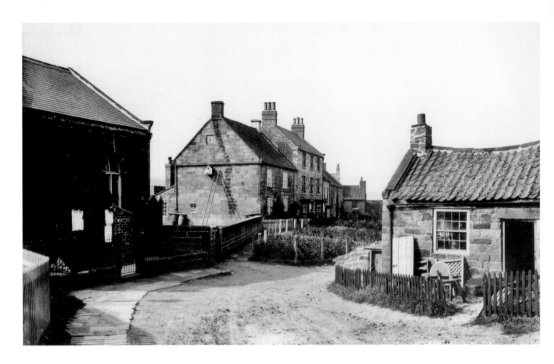

Hinderwell, a Tropical Paradise!

Porret Lane, Hinderwell. Believe it or not, the small, single-storey cottage above is that in the photograph below. Totally transformed, with a second storey added, thatched roof, and complete with exotic palms, it looks more like a cottage found in sunny Devon, or in warmer climates. However, you can tell it's the same scene from the chimney pots of the red-brick house on the left, which has hardly changed through time.

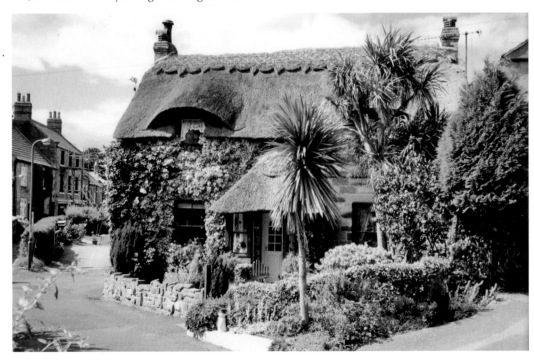

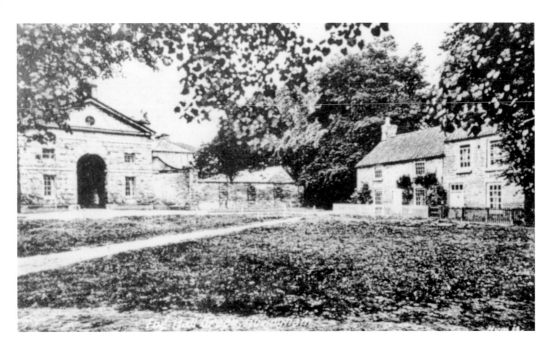

Hovingham Hall, Seat of a Royal Dynasty

The almost unspoilt village of Hovingham is dominated by Hovingham Hall, home of the Worsley family who are related to the present royal family. Hall Green today is altered to give entrance to the hall, built about 1760 by Thomas Worsley, Surveyor General to George III. The main house is reached through the vaulted riding school, erected to exercise his horses in bad weather. Around the south and west perimeters of the estate are woods that are part of the ancient Forest of Galtres, which covered the landscape up to York.

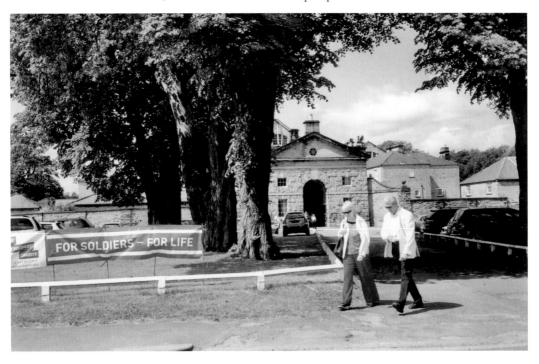

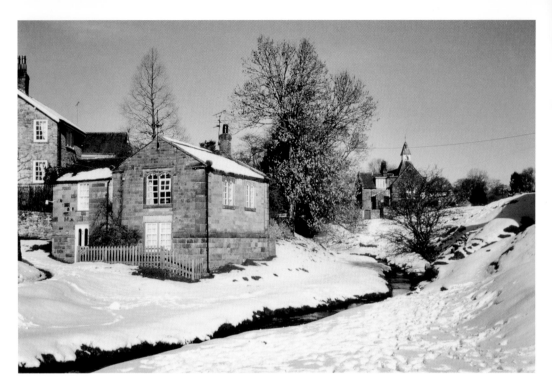

Hutton Le Hole, the Beautifullest of Them All

Hutton le Hole lies in the small valley of Hutton Beck, which divides the village laterally. The traditional stone cottages with pantiled roofs are built around a large green, with white wood fences. Moorland sheep unchecked, keep every corner of the green closely cropped throughout the year. A beautiful village, it is a magnet for tourists all year round. The village school, shop, and post office have become tea rooms and the chapel seen here is now a private residence. Tourism has almost replaced farming in the village.

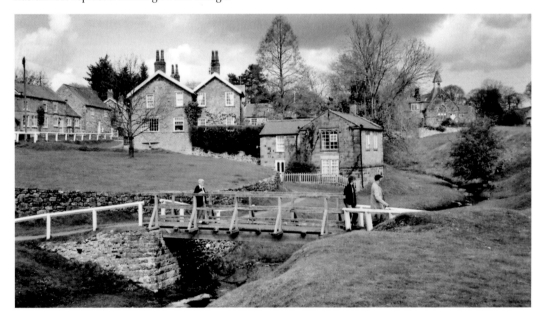

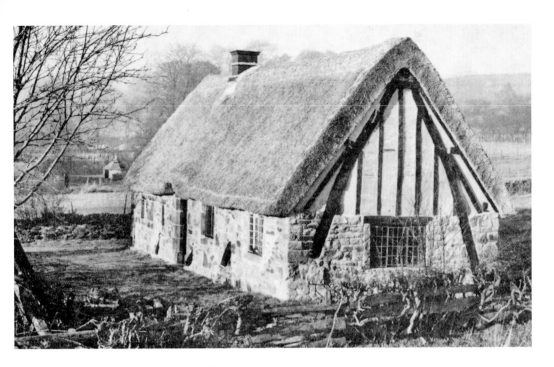

Two Aspects of the Ryedale Folk Museum

The area has been continuously occupied since prehistoric times. That period in history and the story of Hutton and surrounding area is well presented in the buildings and displays of the Ryedale Folk Museum, situated in the heart of the village. Redundant buildings have been carefully re-erected, and a visit is to step back in time and enjoy a nostalgic journey. The museum was opened in 1964 with the gift of a Quaker resident Mr R. W. Crosland, who donated his house, outbuildings, adjoining land and collection of antiquities.

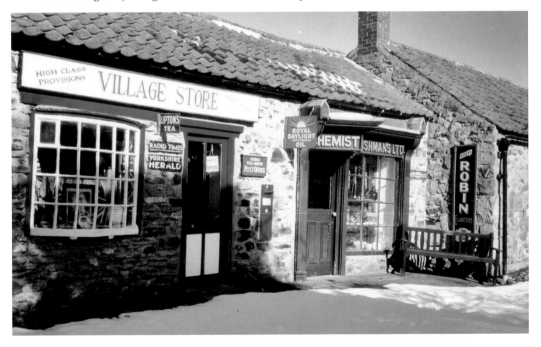

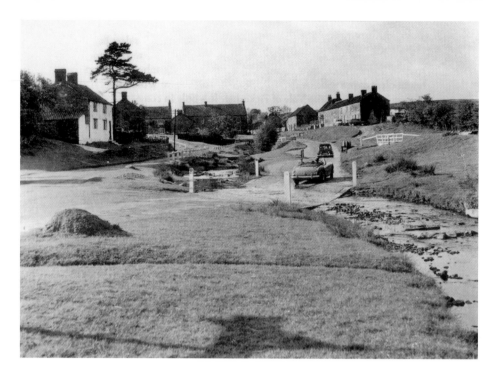

The Changing Faces of Hutton le Hole

At the lower end of Hutton le Hole, the road at one time crossed Hutton Beck via Low Ford (*above*). However, in 1967, the water course was bridged and so came to an end the struggle during the winter months when the beck was prone to flood and often restricted access to the byway that connects with the main road between Pickering and Helmsley. (© North Yorkshire County Library)

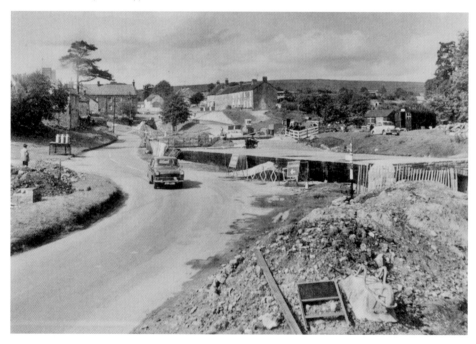

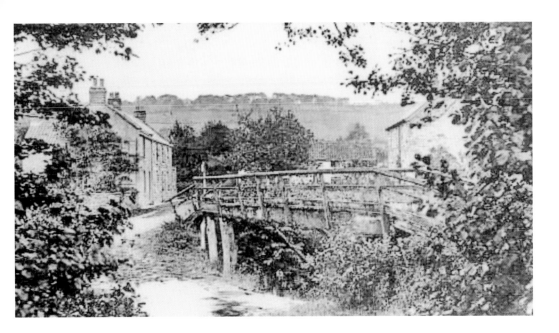

Ancient Crossings at Iburndale

In July 1756, the Surveyor of Ugglebarnby was advised to rebuild the bridge over Iburndale Beck (*above*). A rate of sixpence in the pound was levied on the inhabitants to pay for it. In 1897, this bridge was rebuilt following which, in early January 1899, 'a very large number of workmen who had been engaged in the construction of the new bridge at Iburndale, sat down to a sumptuous knife-and-fork tea at the Station Hotel, Sleights, to wet the keystone laying and to commemorate the practical completion of the work'.

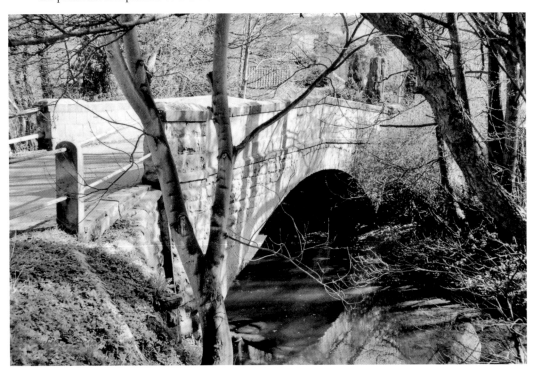

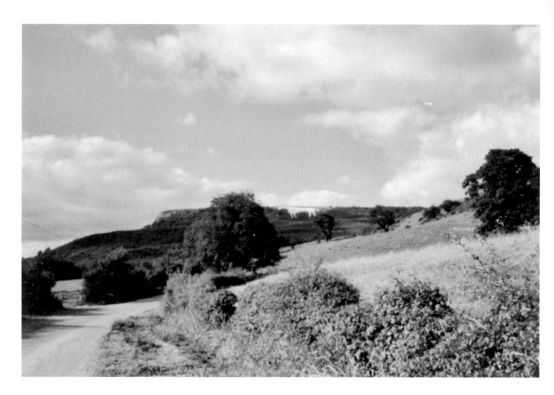

The White Horse at Kilburn

The White Horse of Kilburn was formed by Thomas Taylor, a native of that village. The land on which the horse stands was the property of Mr Dresser of Kilburn Hall. At a length of 180 feet, and height 80 feet, to make a fence around it would enclose two acres. Six tons of lime were used to give his skin the required whiteness. It was completed on 4 November 1857. The figure was simply cut out to gratify the whim of the proprietor, not to commemorate any remarkable event.

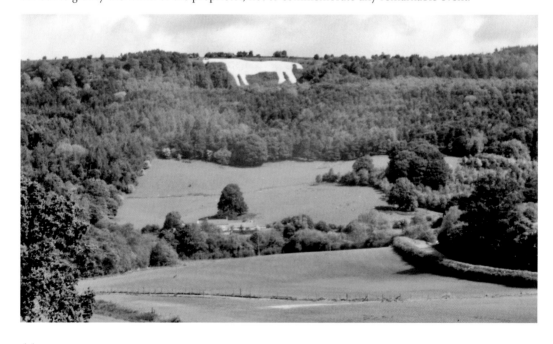

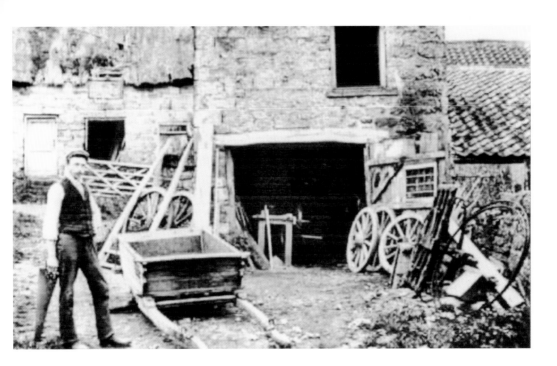

The Mouseman of Kilburn

Kilburn is dominated by the workshop of Robert Thompson, seen above in 1897. A craftsman carpenter, he began making furniture in the classic style of the seventeenth century, no doubt inspired by the Yorkshire furniture maker Thomas Chippendale. Thompson's furniture was almost exclusively made of oak and finished with an adze. This tool creates a distinctive pattern on the surface and emphasised the grain to great effect. His trademark is a carved mouse on every piece he and his staff made. The sixteenth-century timber-framed house was his home and is now a museum.

45

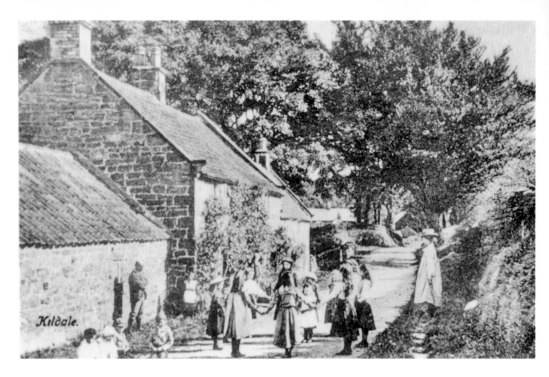

Kildale.

Kildale, Home to Heavenly Twins

Kildale is a small hamlet not far from Great Ayton. The church of St Cuthbert, on the outskirts of the village adjacent to the railway station, was rebuilt in 1868 and just to the west is the site of a motte and bailey castle. However, there are Saxon remains in the graveyard and fabric of the church. Twin sons born in 1769 became famous, each in his own right – William Jennett achieved eminence as a surgeon in London, and Thomas became Mayor of Stockton on no less than four occasions.

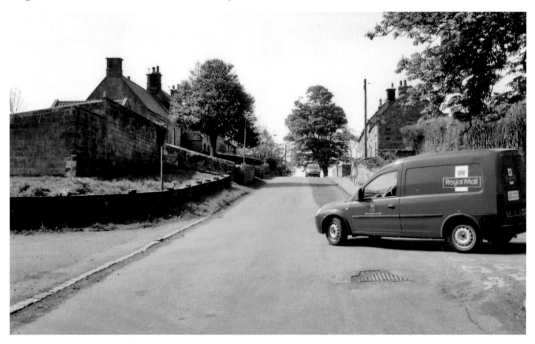

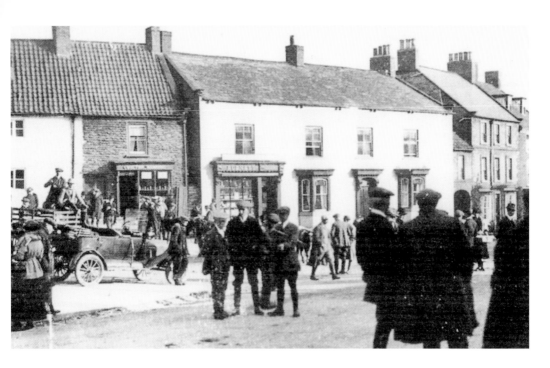

Market Square, Kirkbymoorside

Kirkbymoorside is a prominent market town off the main A170 between Pickering and Helmsley. The manor dates back to at least 1086, when it already had ten farms, a mill, a church and a priest. The wide, cobble-edged main street climbs steadily to the moors. In 1687, the Duke of Buckingham died at 'the best house in Kirkby' after catching a chill hunting on the moors. A street market is still held every Wednesday, under its original charter.

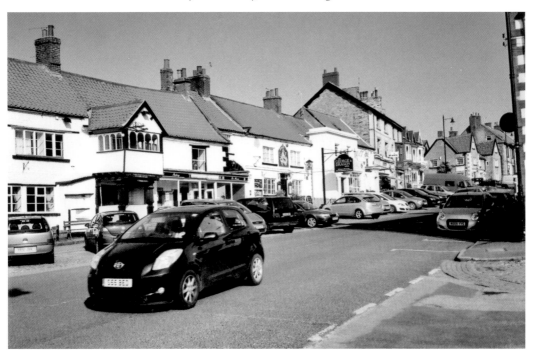

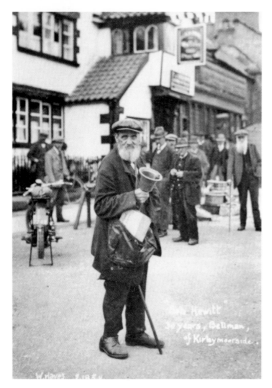

Kirkbymoorside, Hear All About It!
Bob Hewitt, the 'Bellman' or town crier of Kirkbymoorside, standing with his hand bell outside the ancient Black Swan Inn. Today, the inn is a restaurant serving foreign cuisine, open only for dinners. The inscribed lintel below the projecting upper chamber reads, 'Anno Dom 1632: October XI William Wood'. Kirkbymoorside is a significant market townlet and has been for centuries.

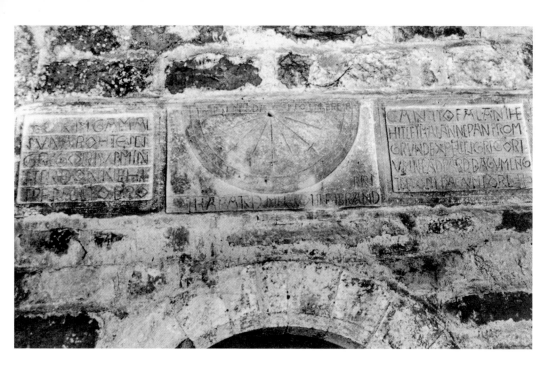

Kirkdale, an Ecclesiastical Timepiece

The Saxon sundial at St Gregory's Minster, Kirkdale, is the best of its kind in existence. The inscription tells how 'Orm, Gamal's son bought St Gregory's Minster when it was all broken down and fallen, and he let it be made anew from the ground to Christ and to St Gregory in the days of Edward the King and Tosti the Earl. And Haward [built it] and Brand [was the] Priest'. The text is in Northumbrian English and dates to the period 1055–65.

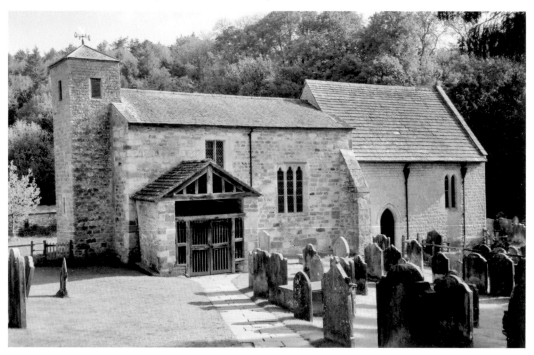

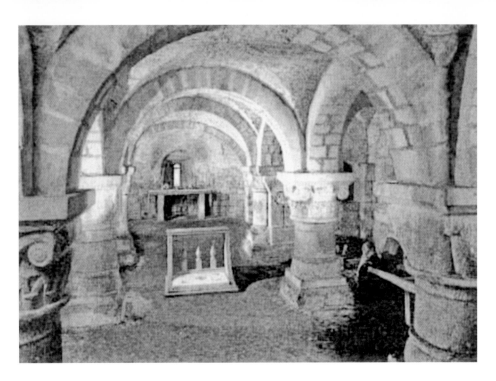

Lastingham, the Holiest of Holy's

Lastingham is an attractive village nestling on the edge of Spaunton Moor. It was in this sheltered retreat that St Cedd, a monk from Lindisfarne and Bishop of East Anglia, founded a church and monastery in AD 654. He was buried here after dying of a plague. The present church was begun in 1228 and carefully restored in 1879. However, the apsidal crypt inside has not been altered for more than a 1,000 years, and is the only example surviving in England with chancel, nave and two side aisles.

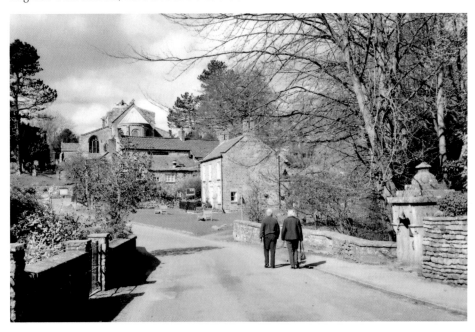

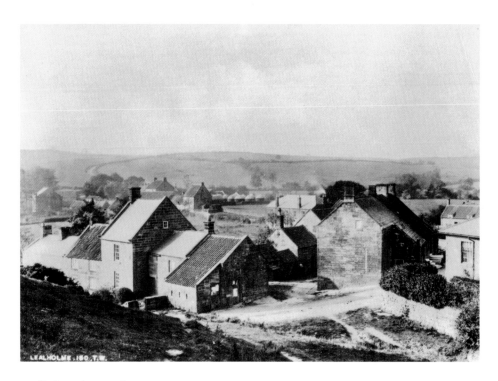

Lealholm, Then and Now

The village centre. Lealholm was mentioned in the Domesday Book, and the name is derived from the Old English meaning 'among the twigs', referring to a time when all this moorland was woodland and a clearing had to be first cut to enable the villages to build houses, and more importantly, a bridge to cross the waters at this point. John Castillo (1792–1845) lived here, a stonemason known as the 'Bard of Lealholm' as he composed numerous rhymes and verse in the dales dialect.

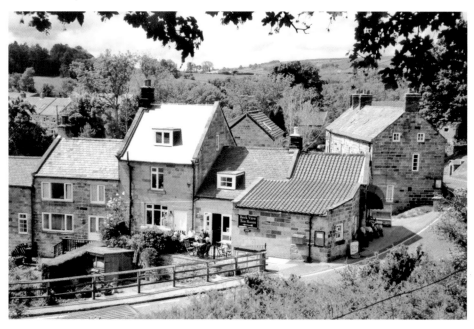

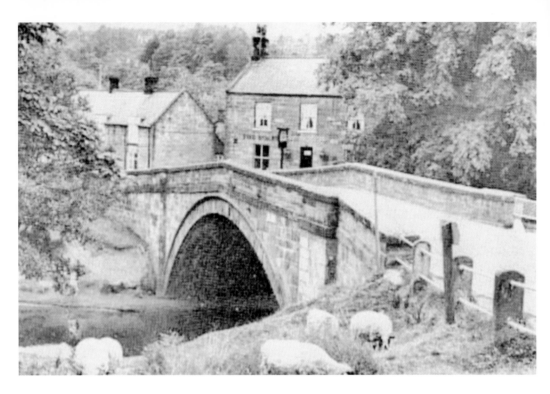

Lealholm, Bridge Over Troubled Waters
The River Esk is crossed here at Lealholm via this attractive eighteenth century bridge. However, despite the numerous times the river rises in flood, in summer it is a pretty place to visit and has an annual 'show' in a field, where the fun is to cross the stepping stones to the field when the water is only inches deep, crystal clear and hardly dangerous.

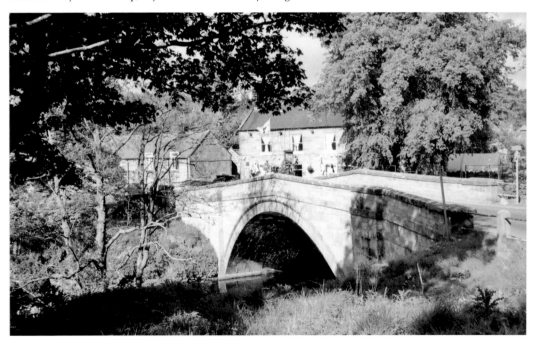

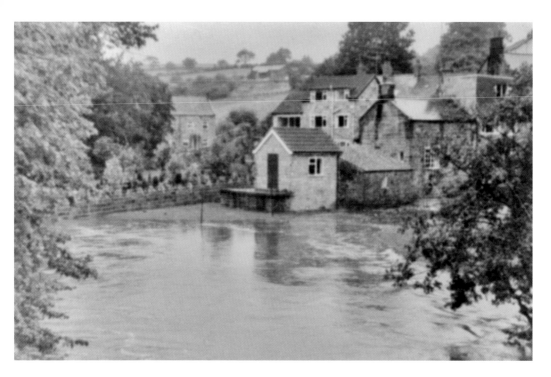

Peaceful and Powerful, the River Esk at Lealholm

Lealholm was last flooded significantly in the year 2000, when the waters rose ten feet. These views are both modern, and show the river here in 1976 within weeks of each other. The River Esk is prone to flooding and has done many times over the decades. Probably the worst inundation occurred in 1930 when numerous bridges were washed away and many properties damaged beyond repair.

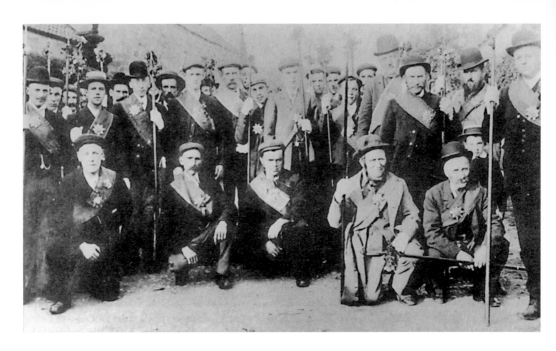

The Shepherd's Hall, Lealholm

In the days before Social Services, the NHS, the 'dole', National Insurance and sickness benefits, these welfare problems were met by local Friendly Societies – often unions of like-minded members who paid weekly subscriptions into a common fund from which they could draw in hard times. In Lealholm, this distinctive buildings is known as Shepherd's Hall, erected with an inscription over the door, by the 'Loyal Order of Ancient Shepherds Friendly Society No. 1343 built 1873' (*above*).

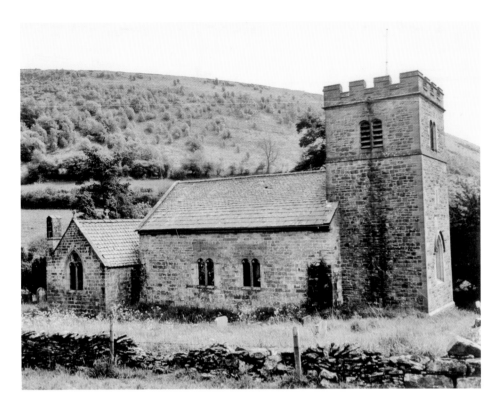

Levisham, Ancient and Modern

The church of St Mary sits in the bottom of the beautiful Levisham Valley, which separates the hilltop villages of Lockton and Levisham. Standing in isolation, it was once the centre of a small hamlet that appears to have shifted to the hilltop in the fifteenth century, possibly as a result of the Black Death. It was in use up until the nineteenth century, when a new church was erected in Levisham village. Various schemes were proposed for the building but it was allowed to become a controlled ruin.

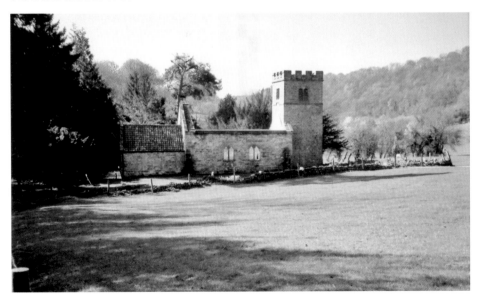

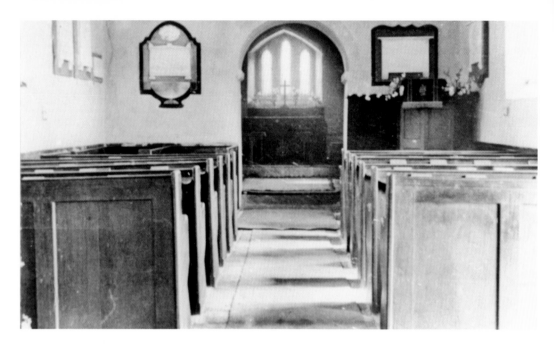

St Mary's, Levisham, a Once Splendid Hall

Despite being restored in 1884, and falling out of use not too many years later, Levisham church has much earlier origins and could possibly date back to the twelfth century. Seen below, stripped of its plaster, is a chancel arch of Saxon or early Norman date. In the exterior walling of the church are numerous pieces of Saxon decorated stonework and a magnificent Saxon coffin was found with twining beasts. There is also the gravestone of a Norman knight inscribed with a sword.

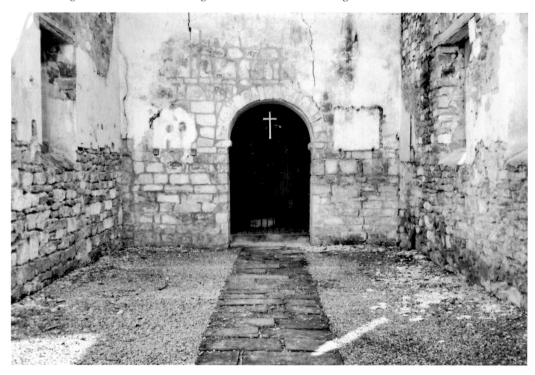

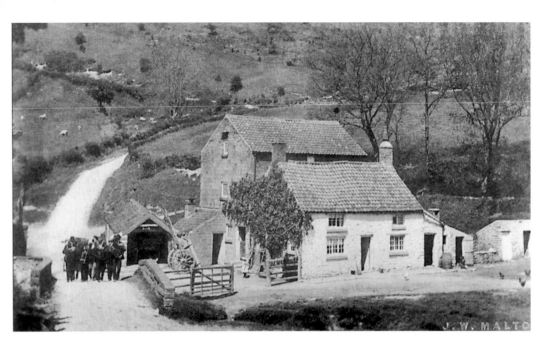

The Changing Face of Lockton

There has been a corn mill at Levisham, powered by the waters of Levisham Beck, since at least 1246 when it is first mentioned. However, the present mill only dates from 1846 but is a fine example of its type and backs onto an eighteenth-century mill house. It last worked in 1963 and the gearing was removed in 1976. The water wheel is still *in situ* and has a 14-foot diameter. There were three sets of grindstones. Some items are now in the mill in the Castle Museum, York.

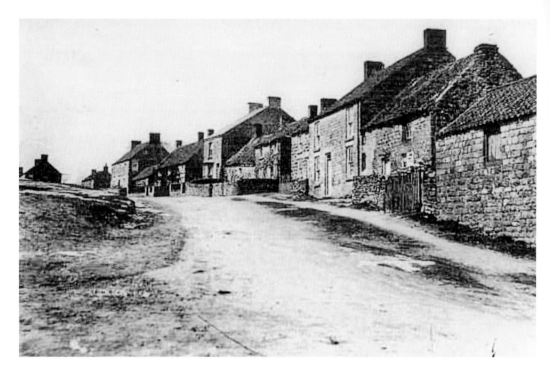

Levisham Mill, and the Band Played On

Lockton is an isolated moorland village that has developed along a single wide, meandering street that leads down the valley and up to Levisham. The church of St Andrew's is a squat thirteenth-century edifice with a battlemented Perpendicular west tower. Many of the village amenities have gone, and the village school is now a Youth Hostel. It did have a pinfold for holding stray cattle until the owner could be found, but this seems to have disappeared. The village green and mature trees create a particular character and charm.

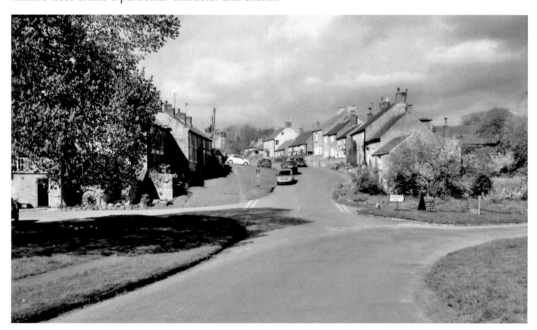

Lythe, a Photographer's Heaven

Although small, Lythe has some interesting connections. The great-grandfather of Rudyard Kipling lived here. Mulgrave Castle, the seat of the Marquis of Normanby, is here and many residents are still employed by the estate. The art of photography figures prominently, and Tom Watson (1863–1957), the son of a Mulgrave estate carpenter, established his studio in Lythe in 1892 (*seen above*). He was a contemporary of F. M. Sutcliffe, the Whitby photographer. Derelict for years, the day I decided to visit to photograph it, it was gone, demolished only two days before.

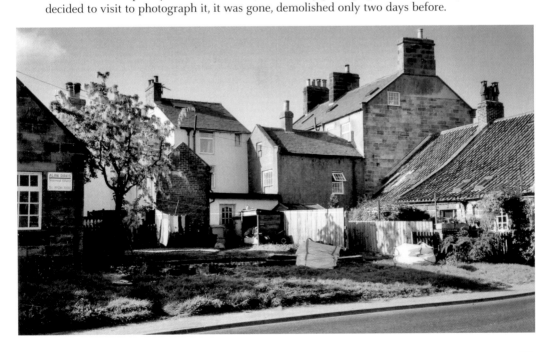

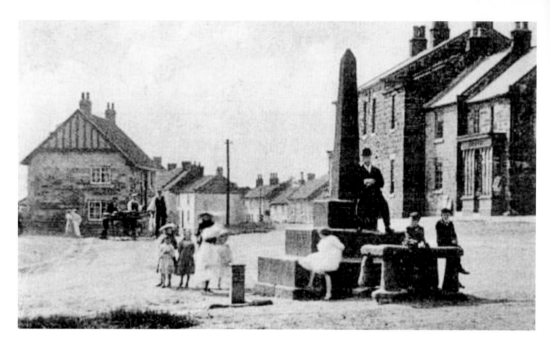

Osmotherley Cross and Main Street

High Street, Osmotherley, taken around 1905. Osmotherley is best known as the western terminus of the famous Lyke Wake Walk. It has always been a popular village with visitors and is a good centre for country walks. A stroll up Rueberry Lane brings us to the Lady Chapel. This was a secret place of worship during the period of Roman Catholic persecution in the seventeenth century. This obelisk, known as the Osmotherley Cross, stands at the T-junction of two main roads and is supposed to commemorate a local legend.

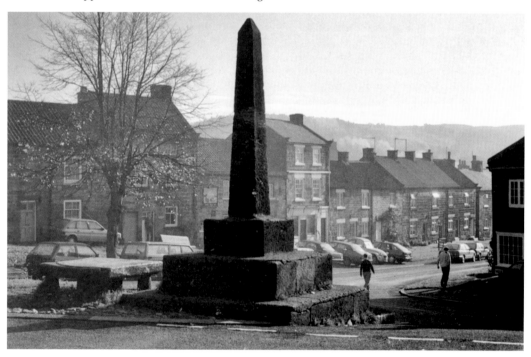

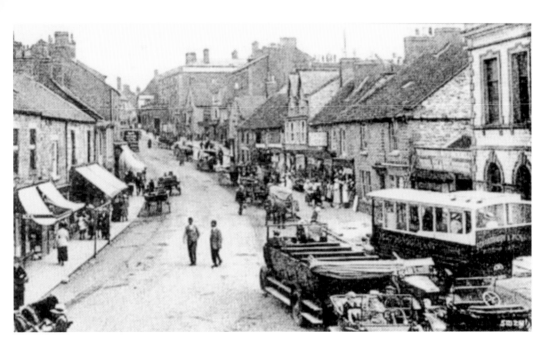

Pickering, Then and Now

Pickering is a small but significant market town, which, according to legend, takes its name from the fact that a ring was found inside a pike caught in the stream which runs through the town. The once thriving cattle market in Eastgate now provides tourist information and car parking. There are the remains of a very fine castle here. The parish church has a dramatic series of medieval wall paintings – some of the finest in England – and the Beck Isle museum was the first agricultural college in the country.

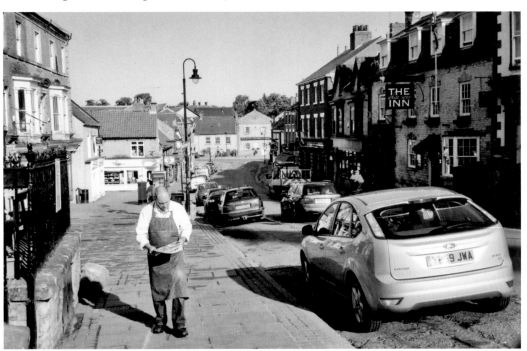

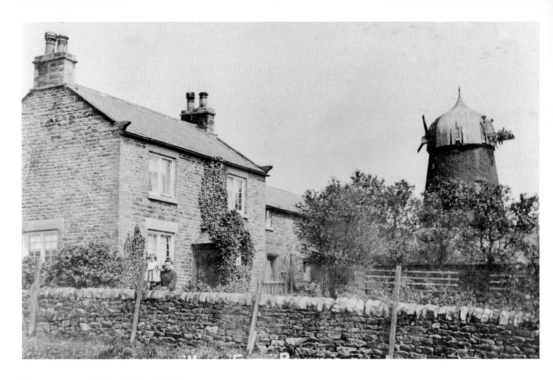

Ravenscar and the Miller's Tale

Ravenscar is situated on the coast between Whitby and Scarborough. The four-storey windmill of stone has the date 1858 carved into its plinth. When newly erected, it was known as Peak Mill and associated with an adjacent inn. Both were leased by Mr Hammond of nearby Raven Hall to the miller and his wife. At what date it ceased operations is not known, nor indeed, when the two properties changed to become Peak Farm. Today, Raven Hall is a country house hotel run by HF Holidays.

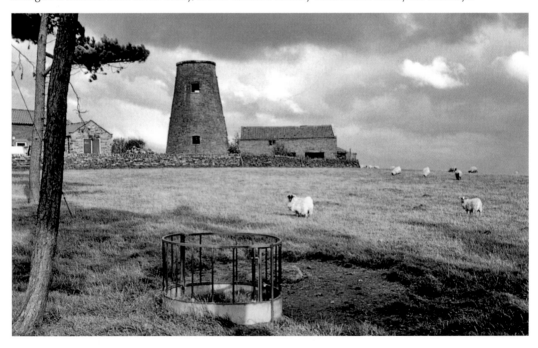

Rievaulx, a Quiet Corner of Yorkshire

The village takes its name from the French, meaning 'The Valley of the Rye'. It was here in this secluded valley that a handful of monks founded Rievaulx Abbey in 1132. Eleven years later, it is recorded that 300 persons were subject to the Abbot of Rievaulx. The village grew to provide accommodation for the large army of craftsmen who worked on the abbey. William Wordsworth and his sister Dorothy visited here in July 1802 on their way to meet William's future bride at Brompton, near Scarborough, where they later married.

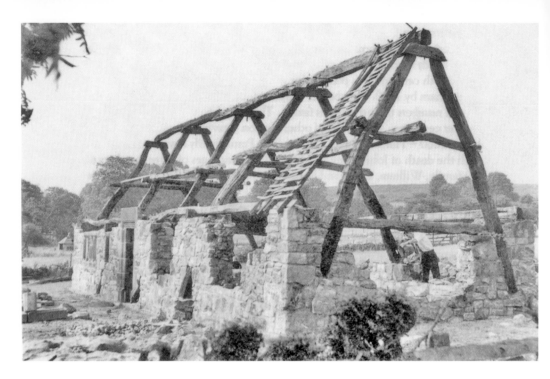

Rievaulx, Bless this House

A rare illustration of a cruck-framed building being erected. The timber cruck frames that support the roof of such cottages are made from oak trees, which have grown curved, and then split lengthwise to form a matching pair. Pairs of cruck frames are held together with the minimum of timber cross pieces. The walls are built up in stone to the eaves level and then the roof of thatch is applied to a framework of interlaced wooden straps. Nothing could be simpler!

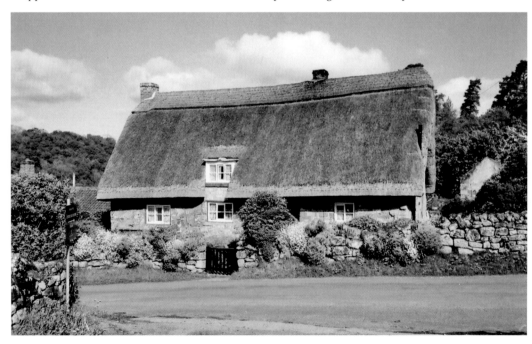

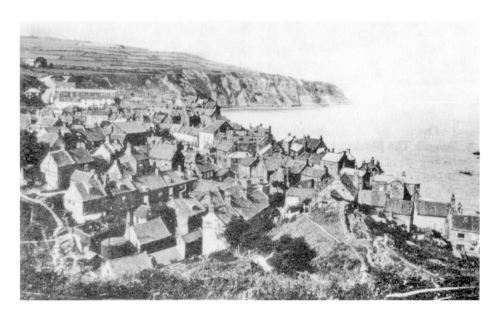

Robin Hood's Bay Named After a Medieval Outlaw

'It lay compact in a ravine whose north-east side was the protecting sea cliffs, and its cottages were so closely packed together the tiled roofs were almost continuous, making a great blotch of red slightly varied by a pearly haze of smoke.' Robin Hood's Bay has changed little since Leo Walmsley wrote this a century ago. There is a timeless quality here in this village of tightly packed alleys and small cottages.

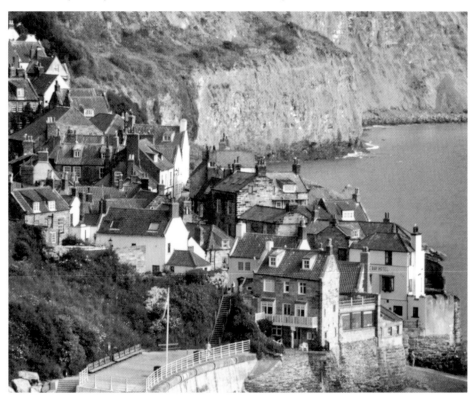

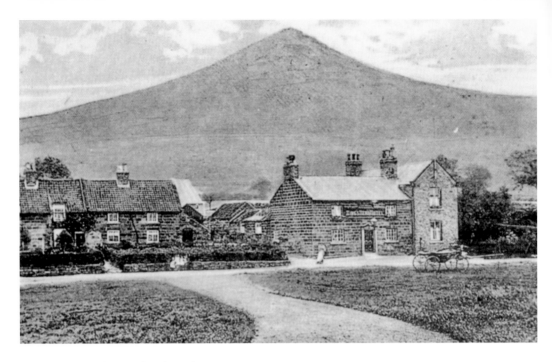

Roseberry Topping, a Sleeping Giant

The absence of a deep scar on the upper south-west face of Roseberry Topping – the result of subsidence due to deep ironstone mining from 1880 onwards – dates this photograph before 1914 when the rock fall occurred. Following the end of the iron-stone mining, it was left with its distinctive profile, familiar to travellers in this part of the National Park on the roads around Great Ayton, from which it can still clearly be viewed.

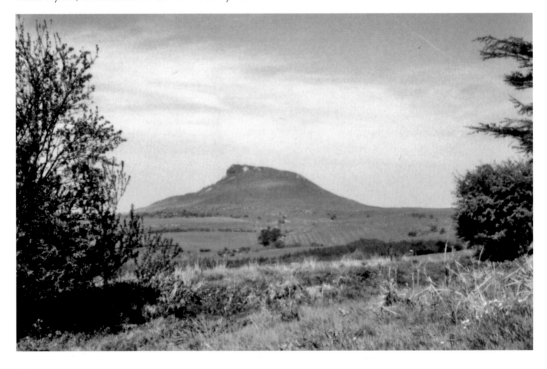

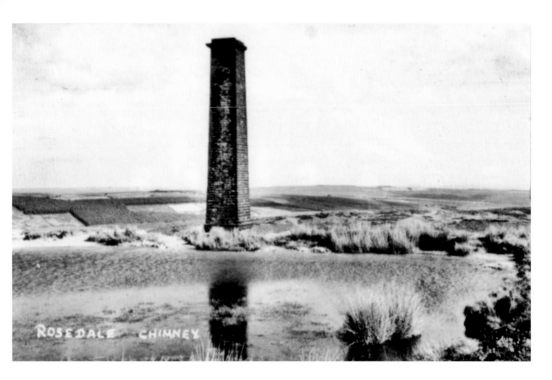

Rosedale, Where the Walls Come Tumbling Down

Standing some 600 feet above the picturesque village of Rosedale Abbey are the remains of massive stone kilns, erected in the 1860s to reduce transport costs for the ironstone mining companies who extracted ore from the dale between 1860 and 1920. The first mine began operating in 1856. By 1861, a railway had been built to carry the ore northwards to the iron foundries. The famous chimney, now demolished, was built so tall to keep the smoke from disturbing the grouse nesting on the moors.

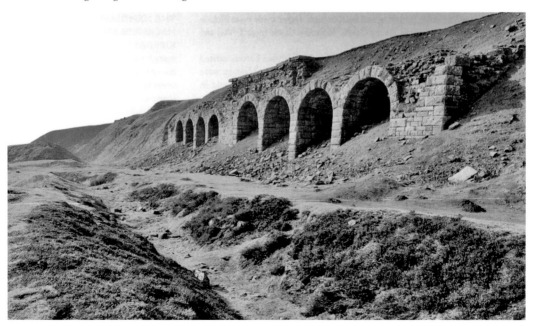

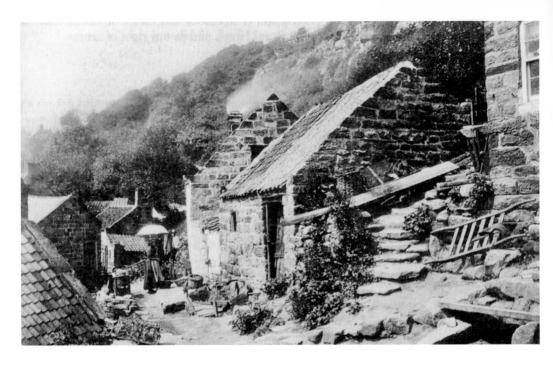

Runswick, an Artists' Paradise

The village of Runswick, generally referred to as Runswick Bay, was for centuries a small fishing community. It consists of a delightful maze of cottages with miniature gardens huddled close to one other and perched perilously on the cliff-side. It was the popular haunt of artists in the nineteenth century. Today, many of the old facilities have disappeared, like the chapel below, which is now a holiday home; as are many of the cottages as Runswick is now largely a holiday village.

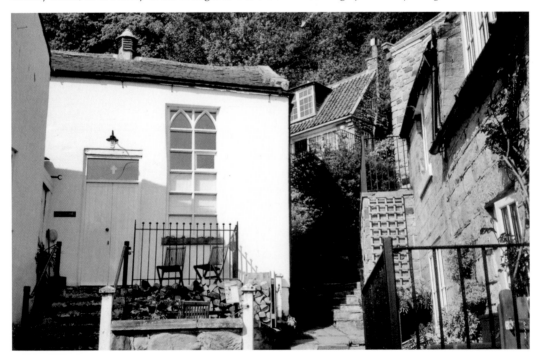

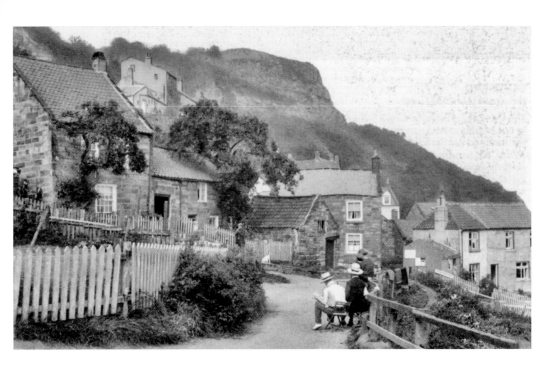

Runswick Bay, Home Sweet Home

At the northern end of the seafront is a thatched cottage, now the only remaining thatched house on the Yorkshire Coast. The street above is hardly changed except for having a coat of tarmac and is the main thoroughfare, barely a car's width. Beyond the bend every vehicle has to stop and large items have to be carried by hand, which is why many of the tiny cottages have a 'coffin window' as they are too small to have proper staircases and coffins have to be manhandled out of the upstairs window.

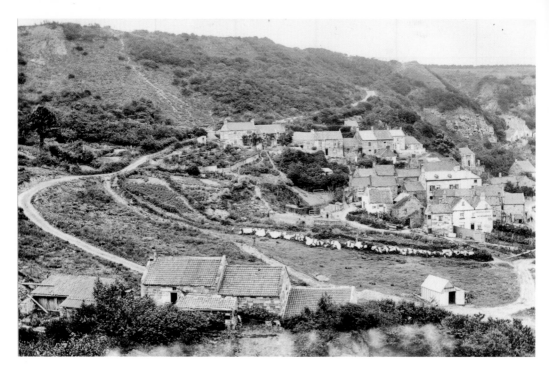

At Runswick, 'Monday is Wash Day, Tuesday is ...'
The relentless power of the sea has over time eroded the softer layers of sandstone and shale to create a rocky coastline. The coast is notoriously unstable. In December 1829, a major landslide to the south of Runswick toppled the entire village of Kettleness into the sea. Runswick itself has not escaped and, at the top end, a road past the hotel ends abruptly where it slipped as the cliffs fell away. The only road into the bay is this one, ending at the Washing Green, were the laundry was laid out to dry.

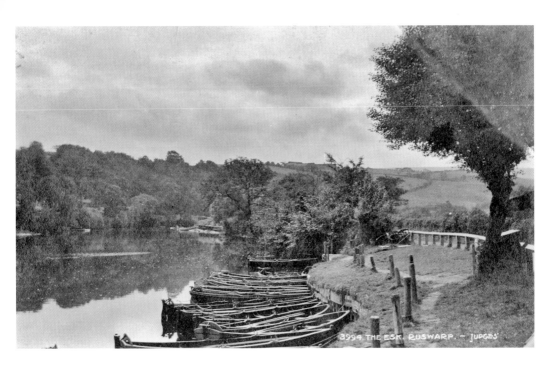

Row Boats on the River Esk at Ruswarp

The above photograph could be the same as the one below, but forty or fifty years separate the two in time. The rowing boats have been a feature of the holiday season at Ruswarp since the nineteenth century. Boats feature in the next Ruswarp scene and, as the River Esk is prone to flooding, these pleasure boats have more than once been used to rescue the inhabitants trapped by rising waters.

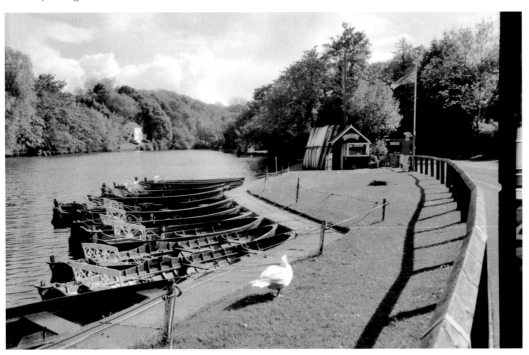

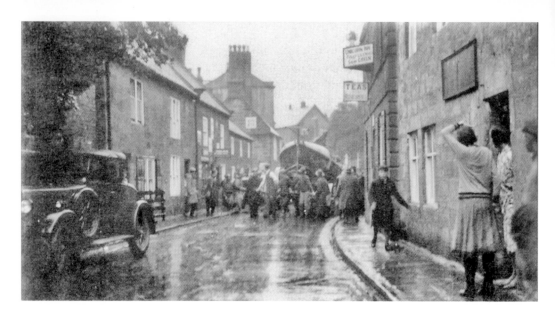

Two Faces of Ruswarp Main Street

During the appalling flooding of the Esk Valley in July 1930, many of the residents of Ruswarp were trapped in the upstairs of their houses, especially along the Carrs. In an effort to assist them in making an escape, the lifeboat from Whitby was sent for, and it was brought inland, pulled by local men and women down the main street of Ruswarp, to be launched into the flooded river. Thankfully, very few were injured and only two persons were lost and drowned.

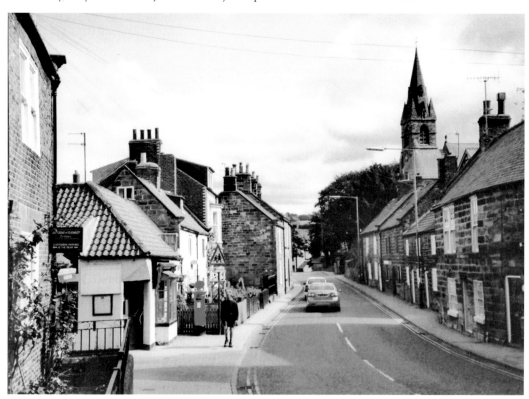

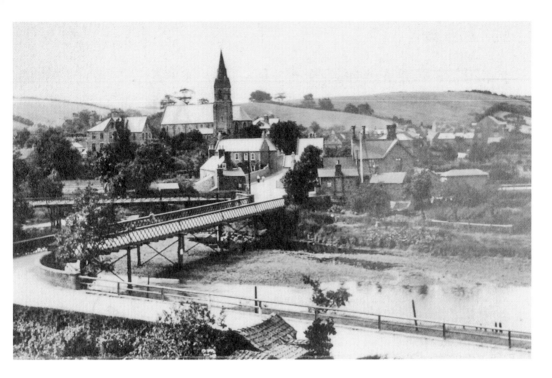

Ruswarp Over the River Esk

A tranquil rural scene over the River Esk. The original road bridge seen above was replaced after flood damage with the distinctive iron girder bridge below in 1933. An interesting feature of the new bridge can be seen in the stone wall leading up to it where, during the Second World War, the bridge name was carefully chiselled off as instructed in order to make life difficult for any invading Germans.

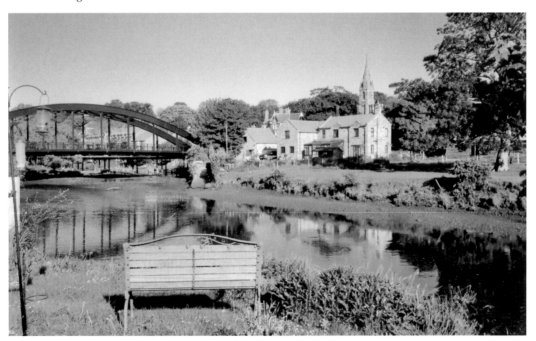

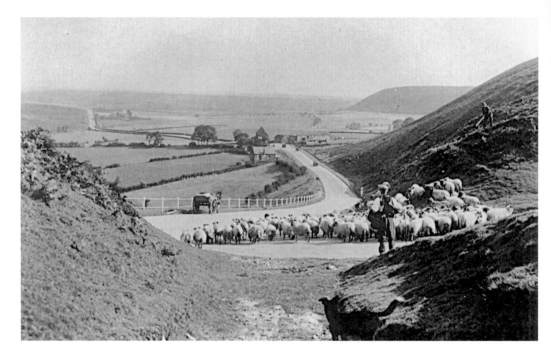

The Wagon & Horses, Once a Welcome Stop

Saltersgate, showing Tom Warriner (*on hillside*) and Dave Harrison (*foreground*) herding sheep. The building on the left, in the middle distance, was Saltersgate School. This closed in 1932 and was demolished several years later. The stone was used in the construction of a new farm nearby. Adjacent to the school was the Wagon & Horses Inn (*below*), which was later renamed the Legendary Saltersgate Inn. Apart from the inn and school there was also a chapel, all of which served a small community here, now gone. (Sidney Smith, Pickering.)

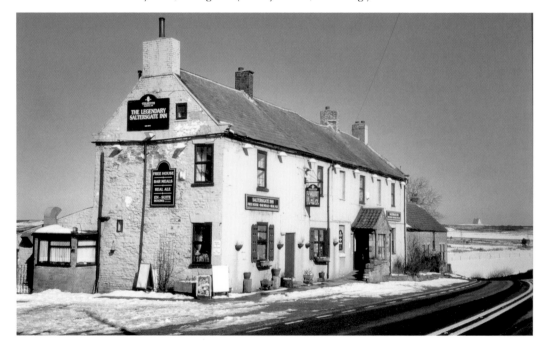

The Fire That Never Died, Saltersgate

Sadly, the famous inn that has stood for centuries is now derelict (May 2011). The fireplace was stolen or removed for safe keeping. The property has had a succession of owners in the last decade, none of whom stayed long. It was put up for auction and sold to a business concern that began to renovate and develop the place to bring it up to hotel standards; however, it is unclear whether they went bankrupt but work stopped abruptly just before the winter of 2010 and it was left roofless.

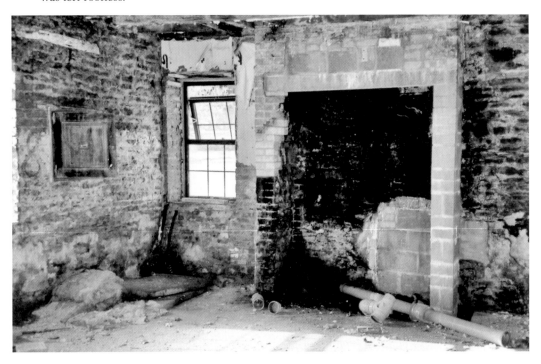

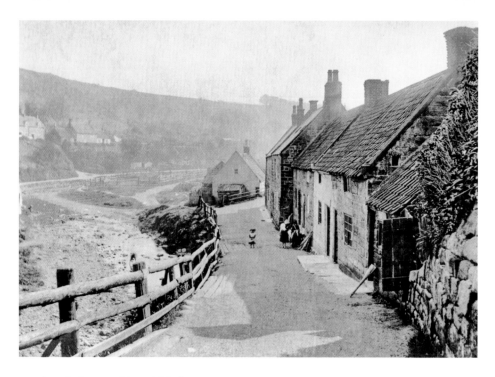

Sandsend, the Jewel in Whitby's Crown

Sandsend nestles at the foot of the steep gradient of Lythe Bank. A village of two halves, each spanning a separate valley, with rivulets running from Mulgrave Woods and joined by a seafront promenade with cottages and hotels. It is hard to believe that this attractive seaside resort was a hive of industrialisation, with alum mines, a factory producing cement, a brewery and a water-powered corn mill. The second valley is a delight, with small cottages and a chapel.

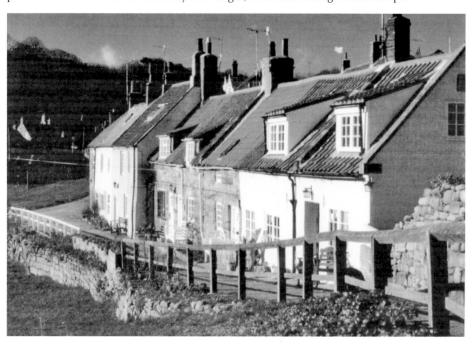

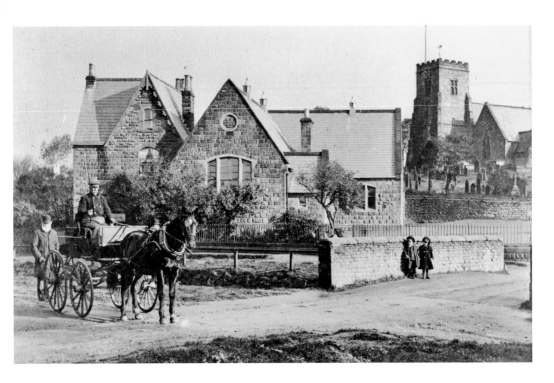

Springtime at Scalby

The lower part of Scalby, where the school was situated and Scalby Beck house. The school butted onto the churchyard and was first erected in 1828; however, the school shown is that dating from 1861. The schoolmaster at that date had to teach a class of eighty-one pupils. The church of St Laurence stands 'upon a gentle elevation at the western extremity of the village ... and is a very picturesque object.' It dates from before 1180, was rebuilt in 1683 and enlarged 1887.

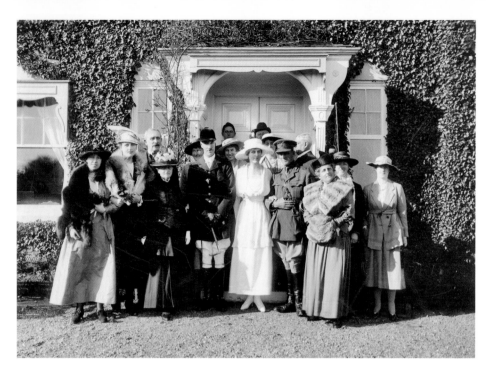

Church Beck House, Happy Days

Mr and Mrs Hardcastle pose for photographs in front of Church Beck House (*below*), their home in Scalby. The bridegroom is attired in his uniform and his father is wearing hunting 'pinks', while his mother is gloriously decked out in a stylish fur cape and muff – possibly of fox fur killed by her husband. A near neighbour to this house was the property of Joseph Rowntree, of the York chocolate makers, which he later turned into a miners' convalescent home.

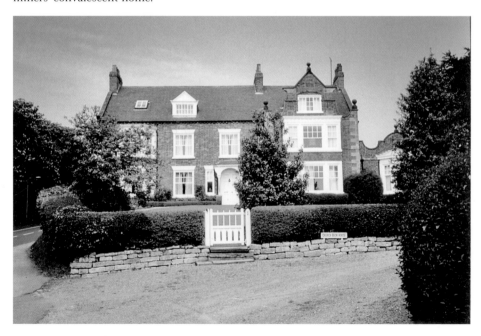

Yew Court, Scalby, an Ancient Glory

Yew Court, Scalby, below, painted in 1875 by John Atkinson Grimshaw (1836–1893), is much as it was above and remains so today, just carrying less ivy. This was one of the more prestigious properties in the village and has had a number of distinguished owners such as Will Catlin, the famous Pierrot, and one half of Marks & Spencer's, Mr Marks, resided here for a period. The gardens were particularly pretty, painted by Grimshaw; and are full of the art of topiary. (© Scarborough Art Gallery)

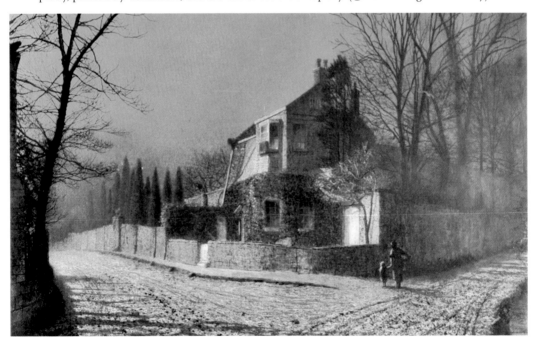

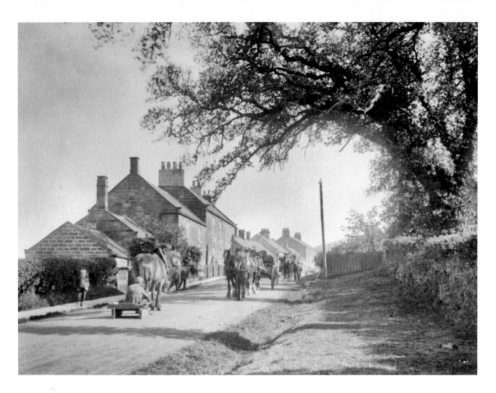

Sleights Village Centre and Coach Road

Sleights village centre. The man is sitting on a sledge that was used to haul stone from the quarries around here, and would be taking his life in his hands with today's traffic. The butcher's and local village store occupy these old buildings today, just as they did a century ago. The same properties, the only differences are the insertion of dormer windows in the roofs – a modern phenomenon.

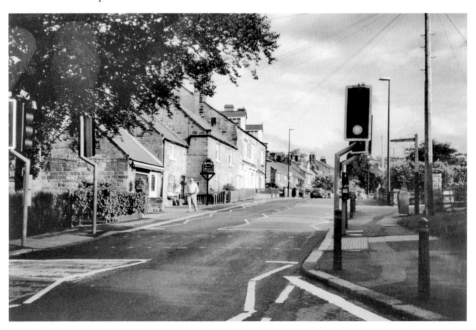

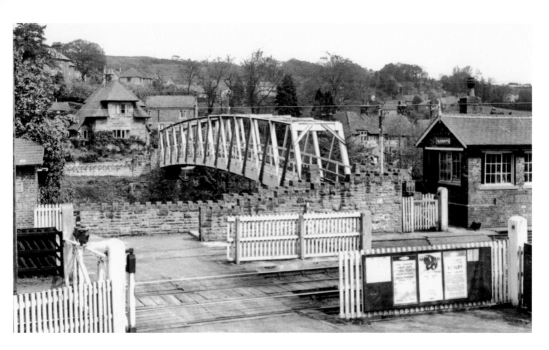

Sleights Railway Station in the Days Before Beeching

Sleights railway station was closed under the 'Beeching Axe' of the 1960s. After closure, gradually things began to slide. A wooden platform waiting room was dismantled and re-erected at Grosmont Station. Tracks were lifted making it only a single track line from Whitby to Middlesbrough. In 1930, the 'ancient stone bridge' over which the road from the moors into Whitby crossed was washed away. Beside the station was a level-crossing. All this was eventually tidied up and now it is hardly possible to tell a level-crossing ever existed here.

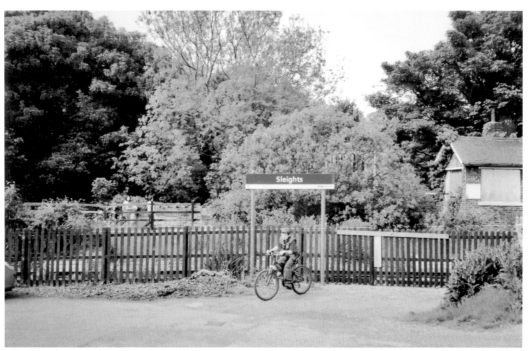

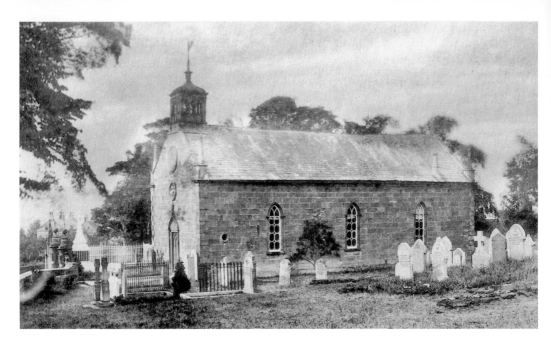

Church of St John, Sleights, Then and Now

This is the old Georgian church of St John, which was put up in the mid-eighteenth century when an even older chapel on Eskdaleside was closed and a more central site chosen. In turn, it was replaced by a Victorian church opened on 20 September 1895 at a cost of almost £5,000. The parish is more correctly known as Eskdaleside-cum-Ugglebarny and served a number of surrounding hamlets – Iburndale, Littlebeck, Ugglebarnby and farms along Eskdaleside.

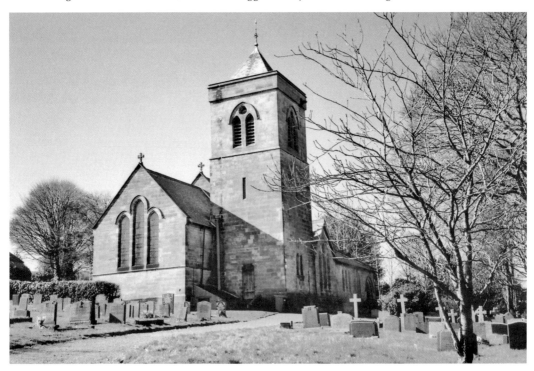

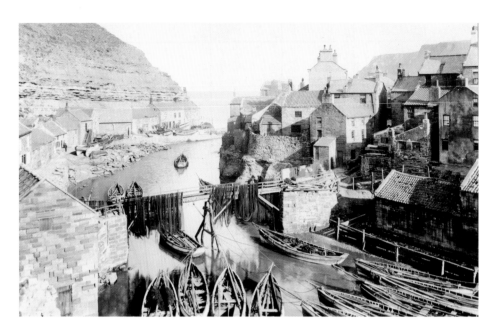

Staithes, a Part of the Captain Cook Story
Staithes is another picture-postcard fishing village, which attracts many visitors. It too occupies a cliff-edge location, with houses and cottages crammed in on either side of a steep main street leading down to the harbour. James Cook served briefly as an assistant in a shop here before he ran away to sea. It is here that Roxby Beck flows out into the North Sea. Staithes was also a major influence in the world of art, and a group of early twentieth-century artists formed themselves into the now renowned 'Staithes Group'.

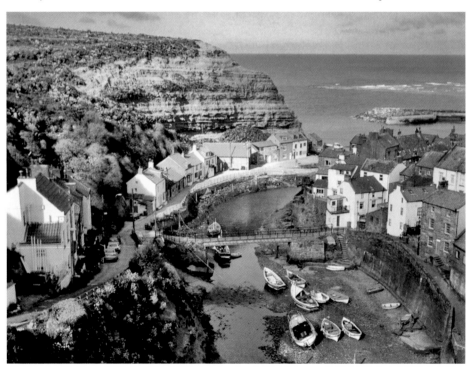

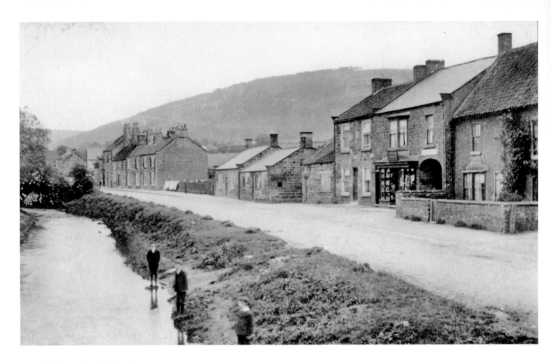

Swainby, a Rural Backwater

Swainby is named after the swains who worked and lived on the estate farms of West Laithes and West Leeths. Roman coins found in the River Leven suggest Roman activity of some sort here. Swainby first appears in records in 1368 and its settlement may be due to the Black Death driving the ten surviving inhabitants down the hill from Whorlton in 1428. Ironstone and jet mining in the mid-1800s led to prosperity and a rise in population.

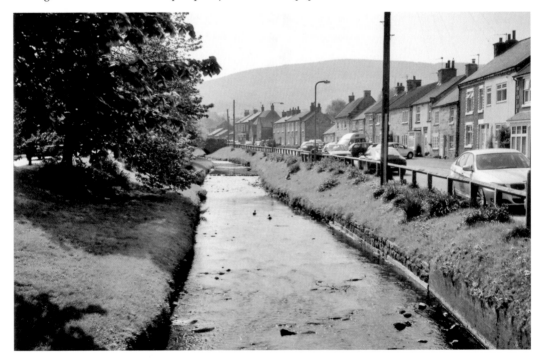

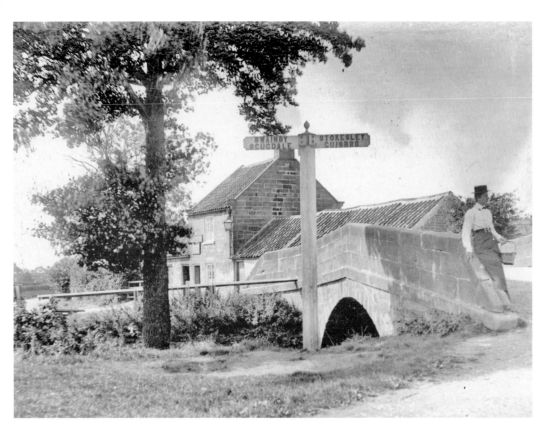

Maynard's Bridge, Swainby, Where Time Stood Still

Maynard's Bridge, Swainby – an obviously posed composition by an unknown nineteenth-century photographer. Unfortunately, when I took this photograph recently from more or less the same position, I could not find a willing passer-by to take the same stance, so my composition lacks the human interest. The village of Swainby is a long straggly affair that runs up both sides of the River Leven and is crossed by three bridges in total, of which Maynard's Bridge is the first or bottom crossing.

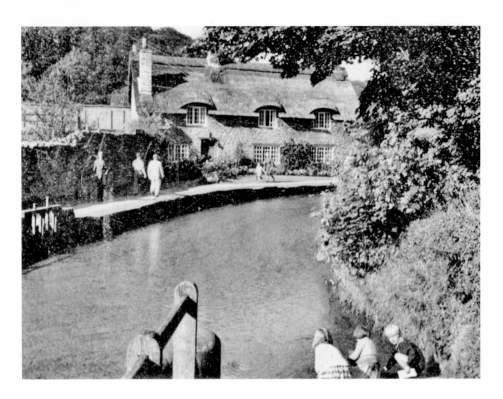

Thornton-le-Dale, a Picture Postcard Village

Thornton-le-Dale is a busy tourist village, and this cottage was occupied by a laundry maid. It is believed to have been reproduced on more souvenirs, calendars, jigsaws, etc. than any other building in England. The roadside stream flows all through the village beside the road, and cottages are reached via small bridges. The lady of the manor, Lady Lumley, founded a grammar school here in 1657. The almshouses close to the school were also founded by Lady Lumley for poor workers on her Thornton and Sinnington estates.

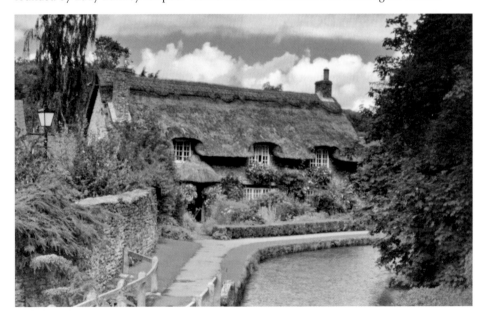

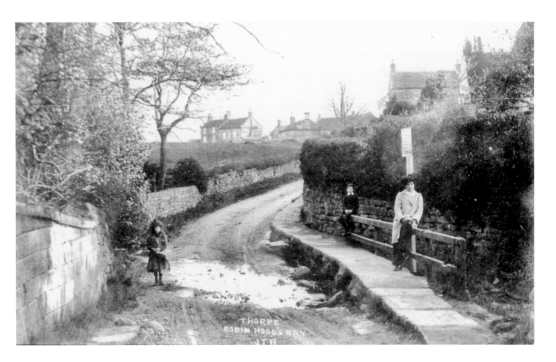

Thorpe, Yesterday and Today

The small hamlet of Thorpe can be found at the lower end of Fylingthorpe, near Robin Hood's Bay. A place of antiquity and charm, there is a very presentable hall at Thorpe dating back to the eighteenth century, if not before. You can see its boundary wall to the left in the upper photograph and to the right in the lower, as this scene of the shallow ford is from both directions, and as can be seen has hardly changed through time.

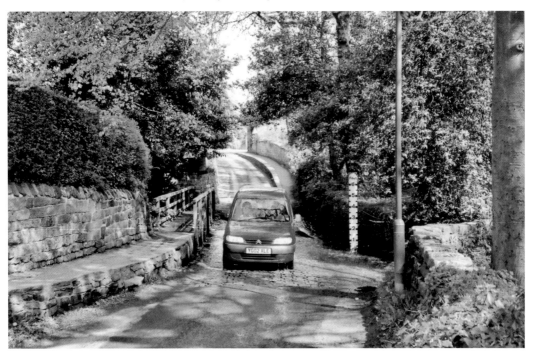

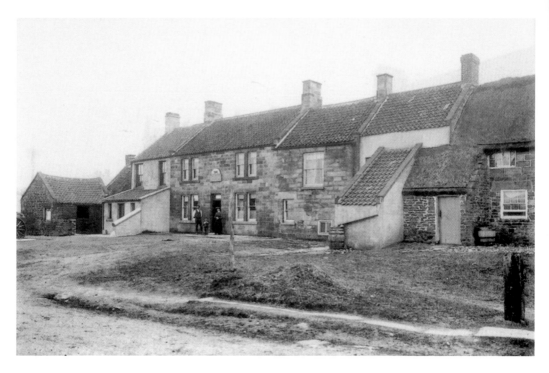

Ugthorpe, Black Bull; Time for a Pint

Ugthorpe is eight miles from Whitby off the main road to Teeside. On the evidence of some coins found in a field in 1792, it is thought that a Roman settlement existed here. In the early 1660s, when Roman Catholics were persecuted, Father Nicholas Postgate lived in a farm on the edge of the village now named The Hermitage. All of the old trades have gone and only the Black Bull remains. A striking landmark of the place is Mill Hill, with the remains of a windmill turned into a cottage.

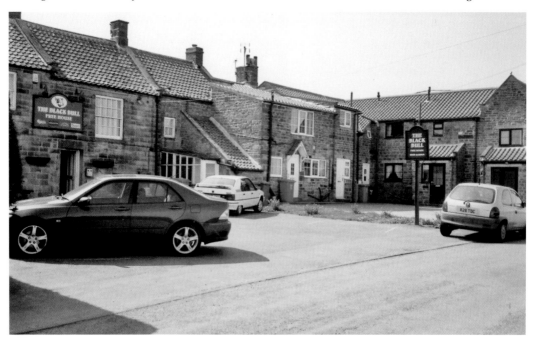

The Two Lives of Ugglebarnby

Ugglebarnby is today, a very quiet hamlet adjoining Sleights. However, during the nineteenth century much mining for coal, alum ore and ironstone went on in the district. As a consequence, there was a 'Doss House' at Ugglebarnby. In the days before poor-law relief and old age pensions it was a night-shelter, as well as a lodging for itinerant miners and labourers who were given work at $4d$ a day with their 'grub', by employers in the parish.

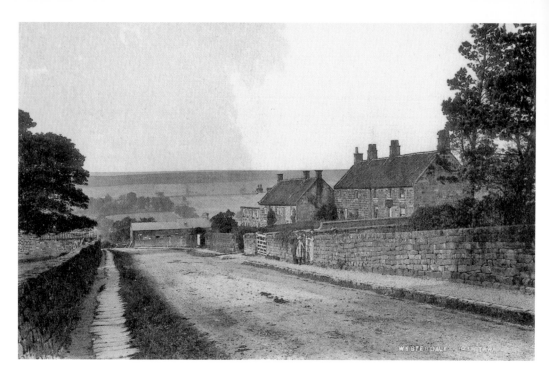

Westerdale, the Remotest of the Remote

One of the highest and most remote places in the Esk Valley is Westerdale and Westerdale village. Here, on a bright clear day, you feel you can touch the heavens. It is a wide dale and through the lower parts the tributary Tower Beck – as well as the Little Esk itself – runs down from the moorland heights into the River Esk, which flows in the North Sea at Whitby.

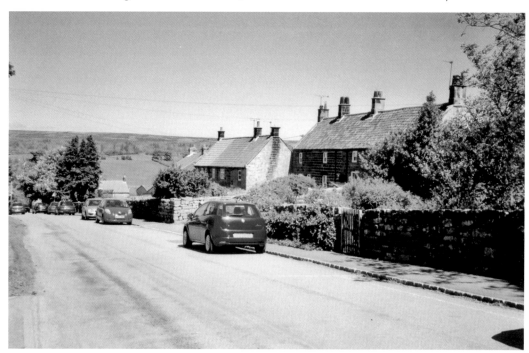

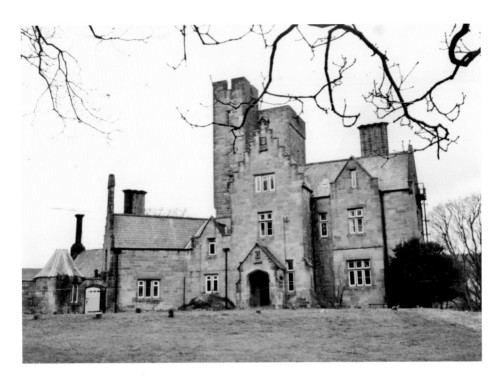

Westerdale, Upstairs and Downstairs

Westerdale Hall, built in the 'Baronial' style of architecture, which gives it almost the appearance of a Scottish castle. It was erected in the nineteenth century as a shooting lodge, later it was owned by the Youth Hostel Association (YHA), and now it is once more a private residence. By contrast, the rear of one of Westerdale's cottages, photographed in 2009. Neither building is any different from when first put up – both caught in a time warp.

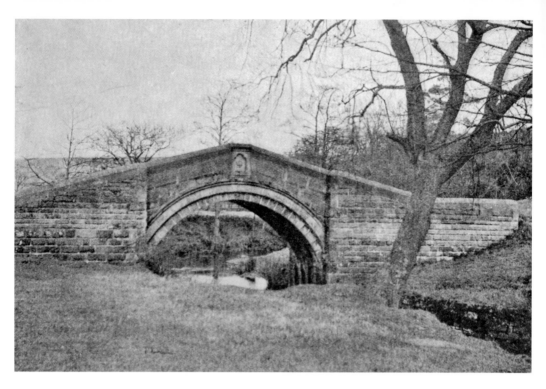

Westerdale, Hunter's Sty, a Victim of Change

This is the first bridge over the River Esk, known as Hunter's Sty. On the western parapet is the Duncombe family coat of arms (of Helmsley), and on the east side is the inscription 'This ancient bridge was restored by Colonel The Hon. J. Duncombe AD 1874'. However, there is no doubt that a bridge was here from the fourteenth century. Today, a new bridge has left this unused by modern traffic and gradually nature is covering it in a green mantle.

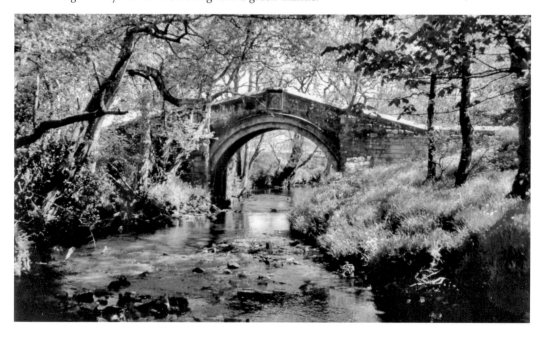

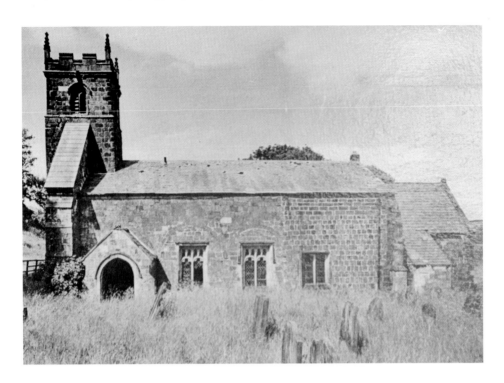

Wharram Percy, Gone But Not Forgotton

Wharram Percy today is what is known in archaeological terms as a Deserted Medieval Village site (DMV). As a DMV, the site has been a major archaeological teaching resource for over fifty years, where students each season came to learn the craft of excavation techniques. The exploration of this village has revealed that it had manor houses, a water-powered corn mill, a dovecote and the church, which was probably the last building surviving in use (*above*). However, today St Martin's is also a melancholic ruin.

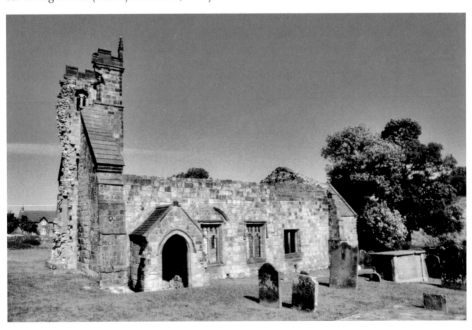

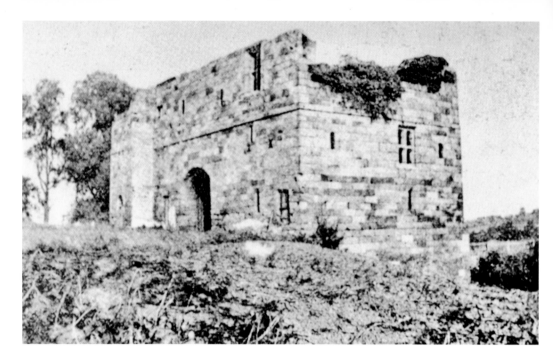

Whorlston Castle, Every Englishman's Home

Whorlton adjoins Swainby; however, today the village site is marked only by the ruined church, and the remains of Whorlton Castle. It is said that the Black Death drove the ten surviving inhabitants down the hill in 1428 to establish Swainby. Certainly Whorlton is more ancient than Swainby. The castle was probably built during the reign of Richard II, and the existing masonry is possibly the work of Philip, last of the Darcy lords, who died in 1419. Today, only the imposing gatehouse and a few walls survive.

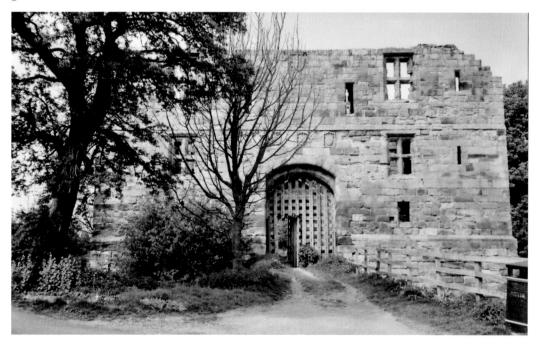

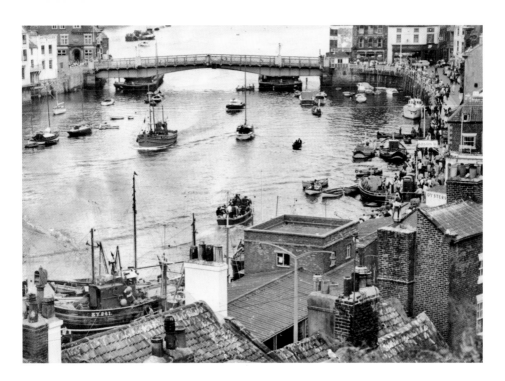

Whitby Harbour, the Old and New

The River Esk empties out into the North Sea at Whitby, where the estuary widens and shallows. The town is still dominated by the harbour, which today is nothing like the size it was in the eighteenth century when the town was the seventh most important seaport in the country. The harbour now covers approximately 80 acres and the upper marina, opened in 1979, can accommodate upwards of 200 pleasure craft. The parish church overlooks the harbour and town below.

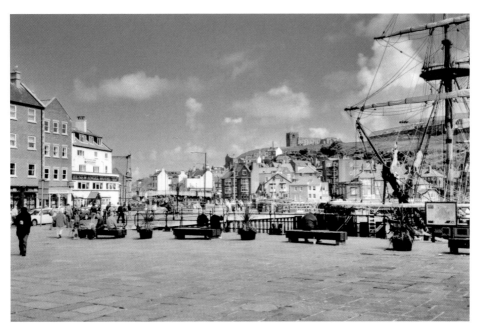

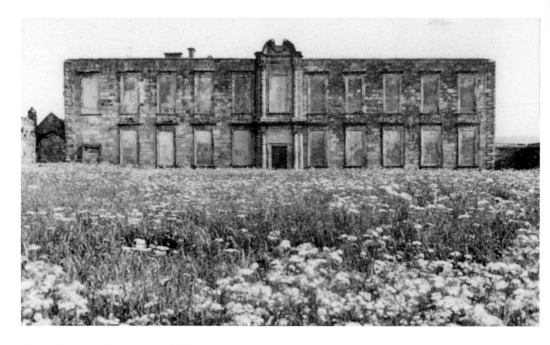

Abbey House, a Once Splendid Mansion

The north wing of Abbey House lost its roof in a gale in 1790, from which time it lay abandoned when the family moved. In 2001, a new visitor centre was created in the shell, window apertures were carefully opened up and a glass 'greenhouse' was erected inside the Grade I listed walls for English Heritage, so as not to cause any damage. Excavation under the grassed area revealed the original Elizabethan pebble-patterned courtyard. Finally, in 2009, a replica of the Borghese Gladiator was set up which was known to have stood here.

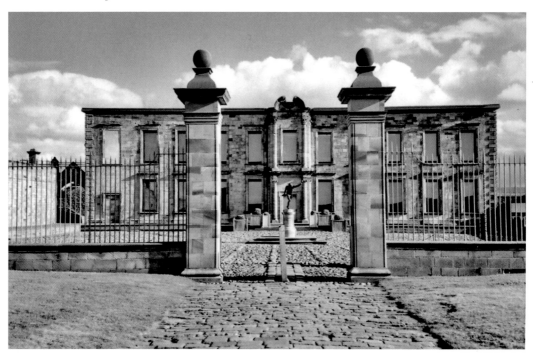